THE COUNTRY CLUB DISTRICT OF KANSAS CITY

LADENE MORTON

THE
History
PRESS

Published by The History Press
Charleston, SC 29403
www.historypress.net

ISBN 978-1-5402-1336-5

Library of Congress Control Number: 2015934849

To Helen Kate and Lucy Caroline, my great inspirations

CONTENTS

CONTENTS

PREFACE

The story of Kansas City's Country Club District was familiar territory to me as I began work on this book. I'd been a professional practitioner in community development for more than three decades. I knew the stats on the district—the country's largest and one of its earliest residential developments, the brainchild of local mega-developer J.C. Nichols, an innovation in planned communities, a study in sustainability. These were the broad strokes of my most common knowledge.

The details began to emerge during my work on *The Brookside Story: Shops of Every Necessary Character*. The stories of the businesses, the people and the events of Brookside stood on their own. But the stories of how Brookside came to be, how it continued through so many years of change and what it has become were all inevitably connected to the greater story of the Country Club District. As part of Nichols's plan for the Country Club District, the Brookside Shops were in many ways the modern face of the district, a remaining example of Nichols's early models, remarkably still mostly true to its original premise. In fact, in some ways, the Brookside identity had sublimated the district's. The "Brookside Area" is the more common name for much of what were the earliest subdivisions of the Country Club District. These subdivisions, now neighborhoods, are still popular and happily more diverse than ever before.

The history of the Country Club District has been presented before. In my opinion, the best work on the subject is the detailed and insightful *J.C. Nichols and the Shaping of Kansas City* by William S. Worley, a work to which this

book owes a great debt. The other, *The J.C. Nichols Chronicle*, the authorized biography by Robert and Brad Pearson, does an excellent job of chronicling the events of the district from the perspective of its creator and the company. This work, *Kansas City's Country Club District*, looks at the history of the district through the lens of J.C. Nichols's original and evolving vision and how that vision was manifested in ways that made it a community of such longevity. While this is a history of a place, the origins of the place all lie with the vision and practical thinking of J.C. Nichols or, by extension, his company. To capture that spirit most directly, the book frequently incorporates quotes and excerpts from original sources. J.C. Nichols was a prolific writer for popular magazines and industry journals, as well as a frequent speaker who kept transcripts of those speeches. He was the lead force behind the Urban Land Institute's *Community Builder's Handbook* and is widely believed to be its principal author. The Nichols Company publication, the *Country Club District Bulletin*, contains Nichols's own writings and the company's commentary on the district. And the Nichols Company published innumerable brochures and informational pamphlets that showcase different facets of the district. Including passages from these materials brings a fresh approach to the history of the Country Club District. They provide an insight into the district from its own time, in its own language and, for me, make the district's history come to life.

There was one other compelling reason for this book. My experience writing about the Brookside and, later, the Waldo communities in Kansas City happily sent me around the city to discuss the books and the histories with a wide range of audiences. These talks invariably included mention of the Country Club District. Too many responses fell into one of two categories: confusion (as in, "The Country Club Plaza? Oh, I love the Plaza!") or ignorance (as in, "What's the Country Club District? I've never heard of it.") These were, for me, clear indications that it was time to revisit the subject.

A Note on
Faye Duncan Littleton

Within this work, I have incorporated a few vignettes that hint at the story of Faye Duncan Littleton. Littleton was an early employee of the Nichols Company who served in several capacities but most notably as the first secretary of the Country Club District's Homes Associations. After the death of J.C. Nichols in 1950, Littleton began to organize piles of ephemera, photos and notes she had gathered during her forty-year tenure with the company. Her final creation was an impressive twenty-eight-volume set of scrapbooks celebrating both milestone company events and the fond memories of a faithful employee. (Subsequent employees expanded the final scrapbook set to sixty volumes.) Interviewed in later years, Littleton was rightfully proud of playing a part in the history of the Nichols Company and of having contributed to its lasting legacy. As a researcher who shares Littleton's passion for this history, I am extraordinarily proud to give Faye a chance to continue playing a part in the telling of this story.

INTRODUCTION

Tucked within the heart of Kansas City is the legacy of one of the grand experiments of American city planning. These acres upon acres of lovely homes built in the early years of the twentieth century are really a model of community building of national historical significance. There are gateways and city limits signs that mark the names of the communities within this acreage, but there is nothing that marks the name of this historical district. It is there nonetheless, and it is Kansas City's Country Club District. The vision and lifelong project of J.C. Nichols, whose eponymous company grew from the success of that effort, the Country Club District set national standards for residential and commercial development that were promulgated throughout the real estate industry during the first half of the twentieth century.

It is true that the Country Club District was not the first of what were sometimes referred to as "garden suburban communities." A few came before it, most notably Baltimore's Roland. There were others like Beverly Hills that became more famous, though during its peak years between 1920 and 1940, no development in the country received more national recognition and praise than the Country Club District. And none of the others—not Roland Park, Beverly Hills or others like Shaker Heights in Cleveland, River Oaks in Houston or Forest Hills in New York—was built on such a grand scale. What began as an ambitious thousand-acre project would be, by the end, an unparalleled six thousand acres. Nor were any of the other planned residential communities actively developed for as

To Those Who Will Study This Map:

THE COUNTRY CLUB DISTRICT, a $100,000,000 project, is not a mere collection of crowded houses but real homes, each of distinctive architectural design, with ample grounds and artistic setting, expressing the owner's idea of beauty, comfort, health and usefulness—in a quiet residential neighborhood, developed according to the standards of modern scientific city planning.

Our comprehensive restrictions are a safeguard, guaranteeing the permanence of the delightful surroundings you will find today. Churches, public and private schools, shopping centers, golf and country clubs, playgrounds, neighborhood tennis courts, a riding academy, bridle paths, foot trails, camp and picnic grounds, extensive park areas, abundant trees, shrubbery and flowers, residents high in personnel and possessing a fine community spirit—these are the elements from which a wonderful home-community has been created.

"COUNTRY CLUB DISTRICT" is a general term and applies to all the properties developed and offered exclusively by the J. C. Nichols Investment Company.

J. C. NICHOLS INVESTMENT COMPANY
COMMERCE TRUST BUILDING

KANSAS CITY

The inset on this 1922 map of the Country Club District illustrates themes the Nichols Company would repeat and reinvent through the 1950s: quality, planning, stability and community. *Missouri Valley Special Collections, Kansas City Public Library, Kansas City, MO.*

long. The Country Club District was a project that lasted more than fifty years.

From a local standpoint, few initiatives in the city's history have had more profound an influence on the broader community than the Country Club District. The district's history begins around 1905, some fifty years after Kansas City's official birth, but at a time that coincides with the formative period of Kansas City's landscape. The city's parks and boulevards were recently laid out; its major monuments and institutions were in the planning. This book focuses almost exclusively on the Country Club District's first fifty years, that period under the leadership of J.C. Nichols until his death in 1950. Although the company survived some fifty years after Nichols's death, it was J.C. Nichols's vision and ingenuity that created the Country Club District as it is today.

The Country Club District lies almost exactly in the geographic heart of the Kansas City metropolis. Yet in its infancy, it was improbably beyond the bounds of the city, just open farm acres south of a tributary called Brush Creek. The area that is the focus of this history is bounded on the north by the Country Club Plaza near Forty-seventh Street along Brush Creek and to the south near Gregory Boulevard or Seventy-first Street, from about Oak Street on the east in Missouri to near Mission Road on the west in Kansas. By the time the Nichols Company ceased residential building in the 1970s, the Country Club District ran from Forty-seventh to Ninety-fifth Streets

north to south and from Holmes Road in Kansas City, Missouri, on the east to Lamar Avenue in Overland Park, Kansas, on the west.

This book offers a look back on the first fifty years or so of the Country Club District. It examines the district as it came into being, by focusing on the elements that are essential to understanding its character. The assessment begins with the idea itself, its creator J.C. Nichols and the company he built to make his vision a reality. Nichols's ideas, in equal part with the lessons he learned as he went along, established the framework for the district. The second element considered is neighborhood development, providing perspective on the nuances of the housing stock Nichols's created and how that has contributed to the district's continued stability. Finally, the book focuses on Nichols's recognition of the profound importance of amenities in the work of creating community, so the stories of the district's schools and churches, its shopping centers and even its physical layout and use in various forms are included.

While most of the original development remains, the Country Club District's identity has diminished. During the period between 1905 and 1950, the Country Club District became an effective and desirable brand in an industry not previously associated with brands. Whether it was a stately mansion in Mission Hills on the north or a working-class house in Armour Hills on the south, the cachet of a Country Club District home made the district the neighborhood of choice for many generations. Today, however, other identities have subordinated that of the Country Club District. Its houses still stand, its neighborhoods remain vital and its shops are still popular. But the notion of what it meant—and means—to be a part of the Country Club District is fading.

If the identity or the principles of Nichols's Country Club District continue into an extended future, it will not be as a result of meticulous preservation of the brick and mortar work of the past. Nor should such preservation be the standard for success. The fact that the Country Club District has survived, with or without popular recognition, is both a testament to all that J.C. Nichols built and to the way in which he built it. This history is as much about recognizing the long-term thinking on which the district was built, using specific tools like fostering a sense of community, creating beauty, providing good services and building homes that would last for more than one hundred years. Nichols himself referred to this as "planning for permanence." Continuing that commitment to a greater vision will be the ultimate test of success and the legacy of the Country Club District.

BUILDING ON A VISION

*There is no more delightful work than creating a city. The most highly civilized
peoples of the world have centered in the cities. The very words city-citizen-urban,
derive their meanings from the same Latin words which indicate refinement,
enlightenment, civility and courtesy. The man who works for his immediate
neighborhood receives less applause than the man who enters the service of his
state or federal government; but after all, that man who strives to make the real
home life of every man, woman and child of his neighborhood happier, has the
greatest of all professions.*
—*J.C. Nichols, "Creating Good Residence Neighborhoods by Planning"*

"I AM HERE NOW"

On the first day of what became the long, hot summer of 1913, an eager and
fresh-faced young woman arrived at the offices of the J.C. Nichols Company
for a second interview. Answering an advertisement for a switchboard
operator—an occupation about which she knew nothing—she had passed
the initial interview the day before. The position offered a salary of nine
dollars per hour for a seventy-two-hour, six-day workweek.

Having moved to Kansas City just the week before, the young woman,
Faye Duncan, was only nineteen years old, so it's not hard to imagine her
excitement at the brink of a new life. Standing in front of the newly built
Commerce Trust Building downtown, where the Nichols Company had

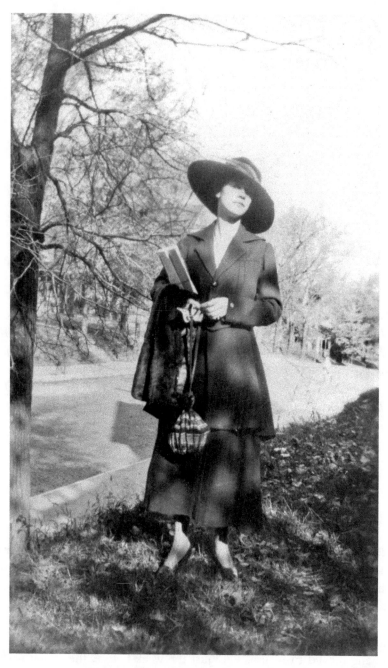

Faye Duncan Littleton, compiler of "The J.C. Nichols Scrapbooks," seen in 1928 on the job in her position as secretary to the Homes Associations of the Country Club District. *J.C. Nichols Company Scrapbooks (K0054 v6p60); State Historical Society of Missouri Research Center, Kansas City, MO.*

recently opened its offices, she would have looked around the city's bustling streets to see many other young women like herself. On the brink of suffrage, women were entering the workforce in ways never known before. Like Faye, they were coming to the cities to find jobs just beginning to open up to women. Jobs like officeworker, shop clerk, teacher or nurse were achievable aspirations, and the economy made opportunities more plentiful.

Faye was optimistic about her prospects, but when she returned for the second interview, she found herself face to face with J.C. Nichols himself. A quiet man who took his business quite seriously, Nichols probably seemed sterner to Faye than was his actual nature. "You have not lived here long enough," Nichols said. "You are not familiar with the names of people, streets, phone numbers and the like." But Faye had been told the day before that there had been few applicants for the job. She knew the company was in a bind to find someone quickly, as the former operator had already left.

"I am here now," Faye answered confidently, "and I can start right away!"

At eleven o'clock that morning, Faye Duncan started her career with the J.C. Nichols Company, a career that would last more than forty years. Even more, her career would make her witness to the life of one of Kansas City's most remarkable business enterprises and to a visionary plan that would change the idea of the American neighborhood: Kansas City's Country Club District.

NICHOLS AND HIS COMPANY, IN THE BEGINNING

Jesse Clyde Nichols, native of Olathe, Kansas, graduate of the University of Kansas and former Harvard Law student, was well on his way to becoming a prominent member of the Kansas City business community by the time he hired Faye Duncan in 1913. The stories of Nichols as a hardworking, bootstrap puller are fair. He had his first job when he was eight and always had at least two or three jobs at any time. In high school, he operated two businesses, trucking produce and, later, running a meat market downtown. He paid his own way to college. At a critical point in his Harvard education, and coinciding with a fateful bike trip through Europe at the age of twenty, Nichols chose real estate development as his profession. He set about learning it from the ground up. Premature timing accounted for his first and only real failure, though his instincts were sharp. He had tried to promote a development in the American Southwest but never got the financial backing he needed.

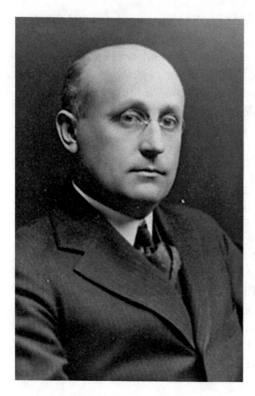

Jesse Clyde (J.C.) Nichols, founder of the J.C. Nichols Company and developer of Kansas City's Country Club District. Nichols is shown here in his capacity as a member of the Kansas City, Missouri School Board in 1922. *Missouri Valley Special Collections, Kansas City Public Library, Kansas City, MO.*

Back home in Kansas City, a devastating flood in 1903 obliterated the river bottoms that link Kansas and Missouri, which in turned opened up an unexpected opportunity to replace worker housing on the Kansas side. It was a small project but enough for a start. Nichols and his early partners, former classmates Franklin and W.T. Reed, formed the real estate firm Reed Brothers and Nichols. The three of them worked the whole development, from sales to construction. Nichols would one day tell the story about taking hammer in hand to build sidewalks with salvaged materials, of selling houses evenings and weekends and of spending nights sleeping in the real estate office.

The only problem with that Kansas-side project was that neither the property nor the market was fertile enough for Nichols's growing notions about real estate development. In 1905, the Reed Brothers and Nichols company spent $8,000 on some land just south of Westport, beyond Brush Creek. Here was property with promise. The site's vantage point on top of the bluff overlooking the creek gave it a view of Oakwood Hall, the stately home of William Rockhill Nelson. As the leonine publisher of the city's leading newspaper, the *Kansas City Star*, Nelson was arguably the most influential man in the city. He also was dabbling in real estate. Nelson hadn't simply built Oakwood Hall; he was also building beautiful upscale homes to surround it. He called the neighborhoods Rockhill and Southmoreland. Nichols called his first development project Bismark Place. It was a mere ten acres that Nichols carved up into four square blocks of housing, and it was just beyond the city limits, so there were

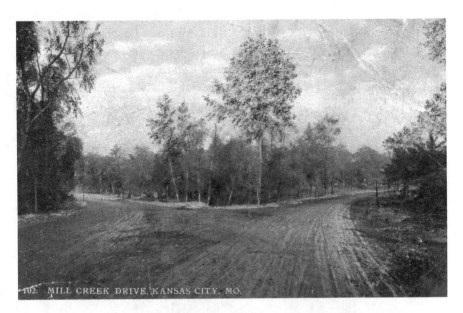

An early postcard captures the raw nature of Mill Creek Parkway in 1908, the year the Nichols Company began development of the Country Club District. *Author's collection.*

no city services. But the city's growth was finally starting to move away from its long-held pattern of stretching out east to west. Nichols could see the city moving in the direction of his building site.

Nichols's ideas about development were teaching him the importance of factors like growth when choosing his projects. For example, there was nothing but farmland south of Brush Creek, so there would be plenty of room to expand his developments farther south. In fact, Hugh Ward, one of the area's more prominent landholders, evidently had so little need for his land that he had given some of it, not a quarter mile from Bismark Place, to a group of the community's elite to use as a golf course. These were the sort of people Nichols was hoping to attract as homeowners, particularly at this early stage in his plan. The icing on the cake of the Bismark Place location was the rail line Nichols purchased that first year he started building. The rail ran south out of Westport, right next to his Bismark Place development, at the bottom of the hill by the side of a brook. Nichols had plans for that rail.

Every instinct Nichols had about the prospects for developing a new residential district in this area of the city had quickly proven right. And every success allowed him to implement more of his evolving vision, the philosophy about development that he would hold throughout his life and the plan that would come to embrace it all. In 1908, he gave the plan

a name: the Country Club District. But even as J.C. Nichols's interest in the nuances of development—construction practices, zoning and land use policies, the importance of aesthetics—were on the rise, the interest of his partners was on the wane. The Reed brothers were finance men at heart. They told their good friend that they would be happy to continue

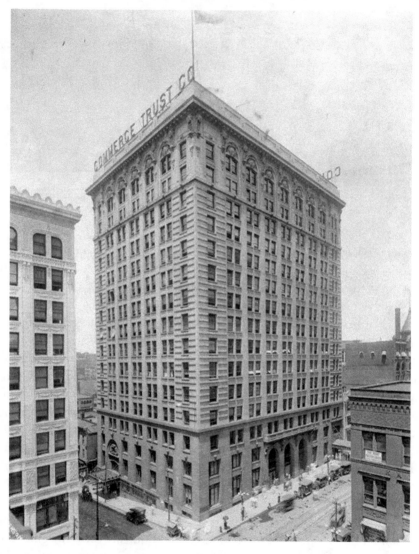

Originally, the main offices of the Nichols Company were not in the Country Club District. From 1912 to 1930, the date of this photo, the offices were in downtown Kansas City, in the National Bank of Commerce Building. *Missouri Valley Special Collections, Kansas City Public Library, Kansas City, MO.*

to work together on individual real estate deals, but they were leaving the development business.

By 1910, the individual businesses, the departments and the corporate structure that would evolve into the J.C. Nichols Company were starting to fall into place. Corporately, there was the J.C. Nichols Investment Company, the J.C. Nichols Land Company and the J.C. Nichols Realty Company, in addition to the flagship J.C. Nichols Company. To have separate corporations for separate purposes was not an uncommon business practice, particularly in the field of real estate, where it could be advantageous to segregate the acquisition, the predevelopment work and the actual construction of housing. With these different entities, the Nichols Company could acquire some tracts and take them fully to development in one instance or merely act as agent for others wanting to develop their own property. On any given day, at any given building site, the Nichols Company might be acting as the broker, buyer or seller of the land; builder for individual homes or whole subdivisions; advisor on public improvements within the district's neighborhoods; or the landlord for the commercial properties.

So in 1912, only a year before Faye Duncan walked in for her first day of work, J.C. Nichols opened the newly formed J.C. Nichols Company in offices at Ninth and Walnut Streets, in the Commerce Trust Building. That location was symbolic of the attention and respect Nichols was garnering within the community. It was also the start of a business and personal association with the Kemper family, owners of the bank, that would carry over into future generations on both sides. In just eight years of operation, the highly regarded Commerce Trust Company became the primary lending partner in the Nichols Company's ventures. The year in which the Nichols Company became a tenant, J.C. also joined Commerce's board of directors, the youngest member by far. J.C. Nichols was all of thirty-two.

ORIGINS OF A VISION

Before entering the real estate business, young J.C. Nichols had been a salesman. Ultimately, he made his fortune selling real estate, or rather selling others on the value of real estate. But he might have made an equal fortune selling other things. Land development was his passion, however, and that passion came from experiences that were both unique to Nichols and completely of his era.

Without development planning, tenements in McClure Flats (lower right) are wedged in between industrial buildings in this 1915 view looking north into downtown Kansas City, Missouri. The Kansas City Star Building is seen about two blocks north of the tenements. *Missouri Valley Special Collections, Kansas City Public Library, Kansas City, MO.*

Nichols grew to maturity at the beginning of the Progressive Era. Beginning in the 1890s, the Progressive Era was a worldwide reaction to outdated institutions and to the failure of those institutions to meet the growing demands of a population dealing with the impacts of industrialization and expansion. The Progressive Era was one of the great periods of reform in all areas of society. This was the era of Teddy Roosevelt's "Square Deal" for labor, his trust busting and his land conservation reforms. This is the period when society clamored for women's suffrage, for prohibition and for better models of education. This was the age of new industry regulations, for meatpacking, for railroads, for foods and drugs. And it wasn't simply that the Progressive Era brought reform. It valued the study of issues, the creation of public policy on those issues and the move toward establishing higher standards of performance in all professions. The Progressive Era thinkers insisted that society take a scientific (or at least measurable) approach to both reforming the old methods and defining new ones.

BUILDING ON A VISION

The Progressive Era generally dates from 1890 to 1920. For Nichols, that means these political discussions about a new world order would have been present from the time he was a ten-year-old boy working for his father at the local Grange office through to when Nichols and the Country Club District were approaching the pinnacle of success. The Progressive Era influences are likely part of what caused Nichols to codify so much of what he did. The land development industry had few internal or external controls. There were no major industry organizations prior to Nichols's time to convene and share experiences and strategies. Neither were there many land development laws at the local level regulating the nature of development. Nichols would be influential in the development of both.

As the Progressive Era likely played a formative role in Nichols's thinking during a long period of his life, his own experiences with the Grange were very likely a specific, early influence at a fundamental level. The National Grange of the Patrons of Husbandry—or "the Grange," as it became known—was a major agricultural movement that was created by a former Department of Agriculture employee in response to the outdated farming practices he saw while touring the Reconstruction South. The central idea was to position local Grange chapters throughout rural America as a method of better communication between the government and farmers and among the farmers themselves. By the time the first Grange in Kansas was organized in 1872, there were more than thirty thousand members nationwide. Jesse Clyde Nichols's father, Jesse T. Nichols, became manager of the Olathe Grange store in 1873 and ran the operation for thirty years. The Olathe Grange gave young "Clyde" Nichols his first job at the age of eight.

The Grange's influence might have been more profound than a young boy's first taste of earned wages and responsibilities. The National Grange movement's philosophy espoused principles that would one day reverberate in Nichols's own development philosophy, among them "promoting community betterment, instilling an appreciation of high ideals [and] teaching through work and play the value of cooperation." The practices of the Grange were as important as its philosophy. As members of their local Grange, farmers stored their crops at community elevators as a hedge against price fluctuations; they bought their goods through the Grange, enjoying bulk pricing; they pooled their earnings into a savings collective that was an early iteration of a credit union; and they congregated for social enjoyment and to discuss cooperative political and economic positioning. Nichols employed these "economies of scale" practices in his home construction

This early poster for the Grange extols the benefits of industry and community. Nichols's experience working for his father, who managed the Olathe Grange, was an early influence. *National Grange of the Order of Patrons of Husbandry.*

work. Among residents of the Country Club District, he always promoted the ideas of subdivisions as collectives, which, acting together, had greater power than if they acted independently when negotiating everything from vendor contracts to city improvements.

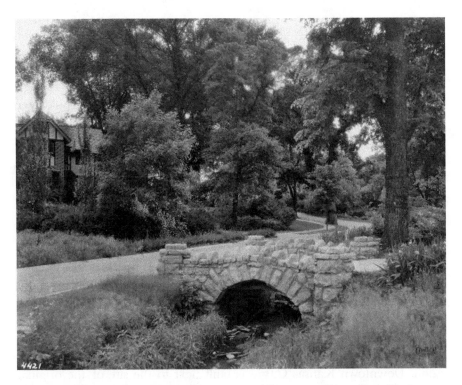

J.C. Nichols's infatuation with the towns and cities of Europe would be reflected in the design of the Country Club District, as in this Mission Hills scene with its winding lane and stone bridges. *Missouri Valley Special Collections, Kansas City Public Library, Kansas City, MO.*

Nichols often credited lessons he learned during his college years as those that most directly led him to a career in land development. Nichols took a bicycle trip through Europe the summer after he graduated from the University of Kansas but just before he was to enter Harvard Law. In the time-honored tradition of coming-of-age travel adventures, Nichols was captivated by all that he saw. And by bicycling and traveling frugally and informally, he experienced it close up, almost as a local. In his later recollections, Nichols would talk about noticing both the grand scale of Europe's monuments and the intimate details that made houses into homes and homes into communities. His course work at both the University of Kansas and Harvard Law were also influential. The classes he took posed ideas that captivated his imagination about how land values were tied to the type of development and how America, unlike its European counterparts, was a country that seemed to quickly discard used land for empty spaces because it had so much empty space to use.

Whatever the mix of these influences, they all came together in Nichols's thinking in ways that gave rise to his ideas for a better approach to land development. These were not ideas that came fully formed from the beginning, nor did they remain fixed. But they were consistent enough throughout his life and career to be fairly called a plan—what he would later call "planning for permanence."

A PLAN FOR PERMANENCE

The factors that influenced Nichols early in his life and career—the progressive times in which he lived, his own life experiences, his education—led him to think more expansively about the role of real estate development. Nichols came to believe that development could bring more than a temporary improvement to land and that it could be used as an instrument for creating a calculable stability in the urban landscape. For years—throughout the country and most certainly through most of Kansas City's early years—development happened without regulation or long-term vision. Downtown Kansas City was built next to the site of the original riverboat landings. Because most of that land near the river was on high, rocky bluffs, deep gouges had to be cut into those bluffs to lay out streets and construct commercial buildings. In places like Quality Hill, stately homes sat with impressive views of the western horizon, as well as views of the muck-ridden riverbeds, fetid stockyards and rusted rail yards of the west bottoms. Housing had to be close to the centers of commerce. There were few commuting options that would have allowed for housing and factories to be prettily spaced far apart. There was no zoning, no land use planning, none of the public policies that in modern times keeps housing buffered from nuisances like belching factories and stench-filled stock pens. Without an organizing instrument like city planning, a builder was likely to find the beautiful homes he had planned to sell at a premium rate suddenly surrounded by industrial neighbors. The value of his property would plummet, and his existing residents would flee to the next latest development.

Nichols's concept of planning for permanence did not come to him wholly formed. He was known to be comfortable trying different techniques, learning from his mistakes and revising. And he was never too proud to seek advice or learn from others. In 1912, Nichols and a few of his key employees, notably his most trusted employee, John C. Taylor, went on junkets around

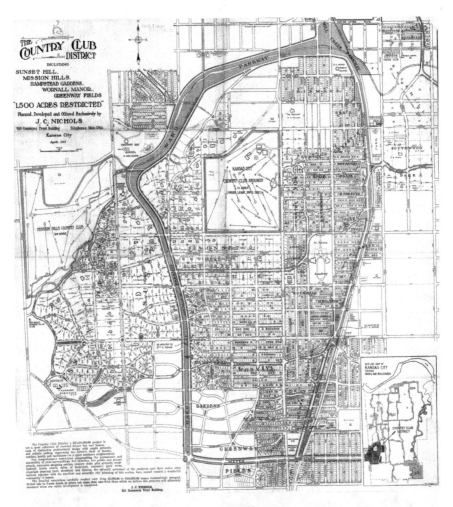

Nichols Company's 1917 map of the Country Club District, including an inset map of the district's relationship to the city's popular Parks Plan. *Missouri Valley Special Collections, Kansas City Public Library, Kansas City, MO.*

the country to see what others were doing in the area of developing "high-class subdivisions," as the industry was now calling them. For the most part, the Nichols team learned what not to do. Their investigation began at home, with the city's affluent neighborhoods, including Independence Avenue, Quality Hill and Hyde Park. They traveled to America's largest cities, from coast to coast and into the heart of the industrial Midwest. The successes they found were modified and applied to the Country Club District. The failures, they vowed to avoid.

The Country Club District of Kansas City

This combination of his own experiences and the lessons learned from others resulted in some basic concepts that are foundational to the concept of Nichols's "planning for permanence." Chief among them is the importance of control. Controlling the character of development was essential to the Nichols Company's goal of stabilizing a property's value over time. Nichols explored many ways of controlling that character, but the most effective—and most controversial—of these was his use of deed restrictions. Restrictions that were assigned to property deeds set rules for a long list of development considerations, from how the house was oriented on the lot to matters related to the property's resale.

A second concept was a strategy for marketing the housing. With deed restrictions in place to mitigate investor risk, the Nichols Company would be able to attract the most affluent and discerning buyers. Nichols's use of the name "Country Club District" was to just such a purpose. By building his earliest developments next to the site of the Kansas City Country Club (then located at the current site of Loose Park at Fifty-first Street and Wornall Road), he was pointedly marketing his development to Kansas City's elite.

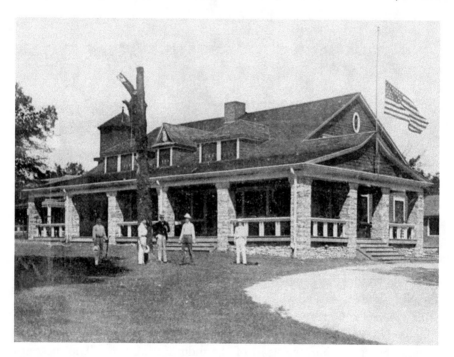

The original clubhouse for the Kansas City Country Club, then located near the current site of the Laura Conyers Smith Rose Garden in Loose Park. *Missouri Valley Special Collections, Kansas City Public Library, Kansas City, MO.*

Their support provided both the capital and the prestige he needed to create momentum for future development. Nichols further believed that once the most affluent buyers were accommodated, the needs of subsequent classes of buyers could be accommodated. In this way, he would build a diverse (and therefore stronger) development, not solely dependent on the rich but accommodating of the professional and working classes as well. Nichols had already seen several major economic booms and busts, and he saw economic diversity as a safeguard against these fluctuations.

Nichols came to believe in the importance of incorporating aesthetics into his development. Unlike the first two principles, this concept was not one Nichols employed from the beginning of the district. Once he did start to incorporate design elements, the idea of an aesthetic took on greater dimensions. The importance of art and design was an element of a Progressive Era worldview that cities had a responsibility for building their civic structures, their public spaces and even their streets with an eye toward beauty. Nichols believed, like many of his age, that it was a duty of cities to

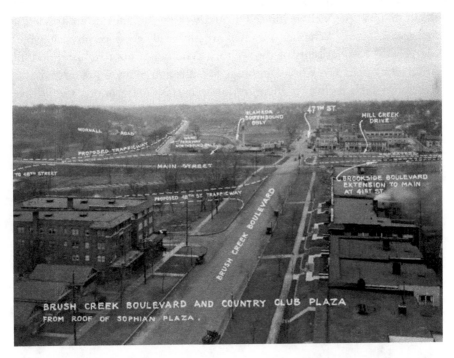

A 1926 view from the top of the Sophian Plaza Apartments at Forty-seventh Street and Oak, looking west toward the earliest buildings on the Country Club Plaza. Anticipating the Nichols development, the city used photos like these to illustrate proposed changes in the road system. *Missouri Valley Special Collections, Kansas City Public Library, Kansas City, MO.*

provide these amenities to all their citizens so that they would be lifted up, ennobled through the experience and inspired to lead enriching lives.

Finally, development needed to be enduring. This was the "permanence" in Nichols's plan for permanence, a forerunner of contemporary ideas of sustainable development. Nichols understood that families moved to new homes if those goods and services on which they relied weren't available where they were. Families wanted to be near churches and schools. Wives wanted family doctors, drugstores and grocers to be nearby. Workers needed to be close to jobs or close to a way to get to those jobs. The Country Club District plan would be replete with conveniences and amenities to ensure its permanence.

In short, J.C. Nichols began to see real estate development as more than a series of individual construction projects. It should be a single, near-seamless development where everything is interrelated, where all important relationships are staked out. It was a monumental vision and a Herculean task, and it would require a new type of company to exert the necessary control and have the enormous capacity the Country Club District development would require. As Nichols himself would write years later in an article for *Architectural Record*, "Whether our cities are physically good, or physically bad is largely the responsibility of the realtors. Whether or not neighborhoods fit into the city plan as a whole, and may live through many years as desirable places in which to live, is their responsibility. Neighborhoods should live through generations."

CHAPTER 2

THE COUNTRY CLUB
DISTRICT NEIGHBORHOODS

*In owning their own home, Father, Mother and the family are apt to be more closely
identified with all questions relating to the welfare of the community, and as home
owners, they feel a certain independence that those who are only transient can never feel.
—Virginia Ruhl, Bryant Elementary School student, from her Grand Prize–winning
essay in the Country Club District's writing contest, "Why Father & Mother Should
Own Their Own Home,"* Country Club District Bulletin, June 1919

Creating a timeline for the development of the Country Club District offers some challenges. Only Nichols's first project in Bismark Place can be dated to a discrete timeframe. After Bismark Place, the growth pattern of the subdivisions becomes more nuanced, and precise beginning and completion dates are impossible to define. In general, subdivisions are dated to when they are legally platted, while housing is generally dated to architectural plans, building permits or utility service. The Nichols Company had plans in the works years ahead of its actual acquisition of property, and acquisition often predated construction by years as well. So it is that the development of individual subdivisions or neighborhoods often does not neatly align to a clear time frame.

Creating a strict boundary for the Country Club District is no less difficult. In early publicity materials, the company stated that the "Country Club District is an inclusive term applying to the properties developed by the J.C. Nichols Companies." Beyond that, the promotional literature doesn't offer much clarity. The company played a variety of roles from one

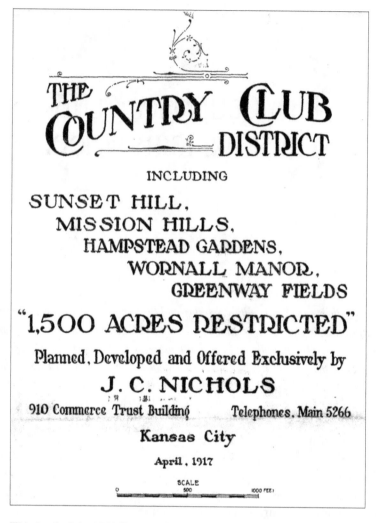

THE
COUNTRY CLUB
DISTRICT

INCLUDING

SUNSET HILL,
MISSION HILLS,
HAMPSTEAD GARDENS,
WORNALL MANOR,
GREENWAY FIELDS

"1,500 ACRES RESTRICTED"

Planned, Developed and Offered Exclusively by

J. C. NICHOLS

910 Commerce Trust Building Telephones, Main 5266

Kansas City

April, 1917

SCALE

This detail of the 1917 Country Club District map highlights some of the company's first subdivisions. Sunset Hill was Nichols's only development not to form its own homes association. *Missouri Valley Special Collections, Kansas City Public Library, Kansas City, MO.*

subdivision to another, serving variously as builder, broker, financial partner and salesman. Early on in its marketing, the company minted the phrase "1,000 acres restricted," but 1,000 quickly turned to 1,500, then 2,000 and onward for the next fifty years. In a later brochure, the company recognized that the term "Country Club District" had acquired such cachet that other developments—and in particular, other home salesmen—were borrowing

that prestige when selling homes not actually in the district. The Nichols Company countered by inviting prospective homebuyers to call its office to verify the claim. But the legacy of these debatable definitions has muddied the question of the district's boundaries ever since.

The Nichols Company's approach to development is much more easily segmented across time, as well as across geography. Building community was always at the core of the Nichols approach to the Country Club District. The Nichols Company held a corporate belief that its model offered a solid, thoughtful approach to providing families with a means toward financial stability and future prosperity through homeownership. From each new subdivision it platted, and each new neighborhood it built, the company learned invaluable lessons it took forward to the next project. And in the J.C. Nichols era of the Nichols Company, the lessons it learned and applied to building the district happened across three distinct periods—from its toddling start to its boom times to its times of strife and challenges.

1905–1918: Lessons Learned, Reputations Earned

The Country Club District began with a small patch of real estate that the Reed Brothers and Nichols Company named Bismark Place. No one had yet thought in terms as ambitious as a "Country Club District." The property lacked obvious appeal. Among its detractions as development property, it was adjacent to businesses that no sane homebuyer would consider as neighbors, including a dairy, a hog feed lot and the noisy, smoke-belching Lyle Brickyard and Rock Quarry. The property was purchased for $800 an acre. The first ten acres were purchased with a three-year loan. The next twenty-one acres were purchased to get rid of some, but not all, of those neighboring nuisances.

There were only four blocks of development in Bismark Place, between Forty-ninth and Fifty-first Streets, Grand Avenue and Main Street. The lots were almost all fifty-feet wide—small by comparison to the housing to come later. Nichols moved himself and his new bride into one of the first two houses. Being outside the city limits, there were no street improvements or utility services. Even water had to be hauled up from the brook to the east. Bismark Place's only advantage was a flimsy claim to being close to affluence. It was within sight of the William Rockhill Nelson development and one-quarter mile from the cow pasture that the Kansas City Country Club was using as its golf course.

A 1917 Nichols Company promotional postcard of J.C. Nichols in his car, inspecting construction at Fifty-third Street just west of Brookside Boulevard. *Missouri Valley Special Collections, Kansas City Public Library, Kansas City, MO.*

In later years, Bismark Place's role as the first Country Club District subdivision diminished. The company would not use the district brand for another few years, well after the Bismark Place project was finished and Nichols had started his own company. But in the company's early promotional materials, Bismark Place is shown as part of the district, while in later pieces it is not. The subdivision's deed restrictions had everything to do with that shift. Developing Bismark Place was J.C. Nichols's primer in deed restrictions, and he learned it well.

The property in Bismark Place had been platted before Nichols and the Reed Brothers purchased the property, which meant they inherited the few restrictions that had been incorporated by the previous developer. As development progressed, Nichols began to find the restrictions lacking, but their most critical weakness from his point of view was their term. Restrictions were generally defined to last a limited and relatively short period of time. In the case of Bismark Place, that was ten years. Nichols quickly determined that ten years was insufficient. It was taking two or three years for interest in the Bismark Place housing to gain momentum. By that time, new purchasers could look into the near future at the end of the restrictions. With only a handful of years left in the term of those restrictions, new homebuyers didn't feel confident. Deed restrictions also needed more detail, particularly

on design-related matters. The specifics of those design-oriented restrictions would take years to refine.

The Country Club District identity was first used publicly by the J.C. Nichols Company in 1908. Nichols used the term "country club" to promote the physical proximity to the Kansas City Country Club and to evoke images of an enticing bucolic setting, a place that was healthy, lovely and conducive to raising a family. These images would continue for years as themes of district living but were especially important during this first phase of the district's development, when the Nichols Company built its highest-value homes.

The Nichols Company followed Bismark Place by platting the neighborhoods directly south, from Fifty-first Street to Fifty-ninth Street, from the rail line on the east (modern Brookside Boulevard) to Wornall Road on the west, with Main Street initially serving as the central artery. On the west side of Main Street, nearer the golf course, Nichols continued his pastoral themes in choosing the names of Country Side, Country Side Extension and South Country Side for the subdivisions he platted there.

On the east side, along the gentle slope that led down to that brook running next to the rail line, the neighborhood plats shared the name Rockhill: Rockhill Place, Rockhill Park, Rockhill Heights. J.C. Nichols famously pushed his luck with William Rockhill Nelson, Kansas City's revered newspaper publisher. One of Nelson's own nearby developments carried his name as well: Rockhill Homes. A face-to-face meeting between the two men ultimately resulted in a longtime friendship and a strong civic alliance on future matters. But Nichols never applied the name "Rockhill" to another of his neighborhoods.

Everything about these new neighborhoods was different from Bismark Place. Where Bismark Place is laid out in a grid pattern, with the long side of the block oriented north and south, the new subdivisions were on an east–west layout, with the advantage of more southern light. The basis for the street layout was still gridlike, but there were a few well-placed winding roads that swept a graceful, ribbonlike diagonal through most of the subdivisions. The layout prevented all homes from lining up so squarely that they seemed mass produced and unnaturally placed. The Nichols Company was now learning lessons about creating value in property through design, by keeping the natural contours of the land to create more interesting approaches instead of grading everything flat and drawing every line straight.

Nichols became adept at forging working relationships with the area's longtime property owners. The ancestors of these owners built the city's fortunes during the days of the overland trails or came later, as captains

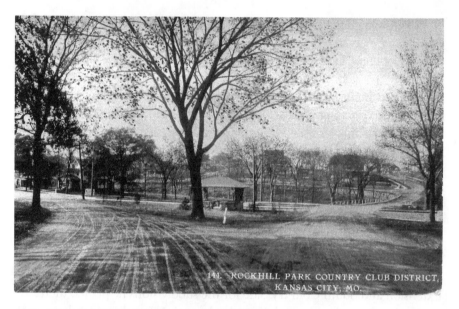

About 1910, the Nichols Company commissioned this early postcard, illustrating the new (if rough) roads that had been laid and the convenience of the streetcar shelter serving the Rockhill Park subdivision. *Author's collection.*

Another of the promotional postcards distributed by the Nichols Company, this one for the Country Side subdivision, 1909. *Author's collection.*

of the city's new industrial and transportation ventures or as investment tycoons who served them all. Some families may have lived on the properties, but for the most part, these were tenant farms or grazing pastures, not traditional homesteads. These property owners lived downtown or in the fashionable northeast area or Hyde Park. They were eager to make money from their absentee landholdings. In his time, Nichols dealt with the descendants of many of the area's most famous overland trail traders and suppliers, including names like David Waldo and John Bristow Wornall. But it was Nichols's relationship with the family of Seth Ward that would prove the most pivotal, both for the development of the Nichols Company and the growth of the Country Club District.

Nichols's partnership with Hugh Ward, the son of Santa Fe trader Seth Ward, was the basis for the Sunset Hill development and would ultimately lead to the preservation of an important piece of local history. Ward owned more than four hundred acres between today's Wornall and State Line Roads, running south from the bluff that overlooks Brush Creek. Years before, when the property was in the hands of the famous western frontiersman William Bent, the property was the site of the Battle of Westport, one of the largest campaigns of the Civil War west of the Mississippi. Not thirty years after that bloody battle, when the local members of the Kansas City Country Club were looking to relocate from their course near modern Thirty-ninth Street and Gillham Road, Hugh Ward offered up a part of that battlefield—now his cow pasture—for the club's new golf course.

In 1909, the Nichols Company formed a partnership with the Ward Investment Company to develop some of its acreage around the golf course into a new subdivision. In that property, Nichols saw the beautiful Brush Creek overlook facing west, which suggested the name of the subdivision: Sunset Hill. This was the high-end development Nichols needed to make the Country Club District work as he was starting to envision it. This would attract the sort of buyers whose mere purchase of the property would signal to others that homes in the Country Club District were a stable investment.

Three years after Sunset Hill development started, work began in Mission Hills, the first project the Nichols Company initiated in Kansas. Together, they are home to some of the most valuable residential property in Kansas City and some of the finest examples of the architecture and design of the Country Club District. In these early years, the Nichols Company was already creating extraordinarily fine promotional literature. One of the earliest examples of this was the brochure created to promote the Sunset

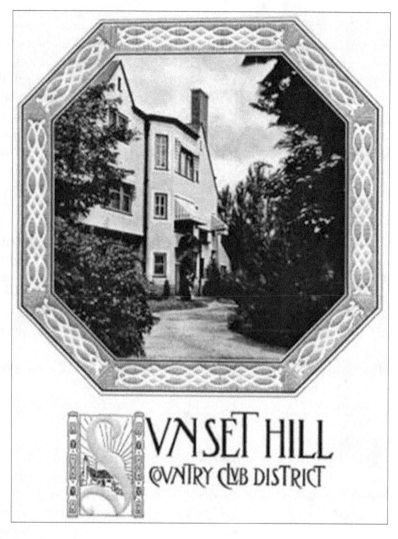

An early sales brochure for the Sunset Hill subdivision, one of the Nichols Company's first subdivision projects. *Missouri Valley Special Collections, Kansas City Public Library, Kansas City, MO.*

Hill neighborhood. As the brochure's introduction illustrates, the company was never modest in its assertions or shy about its offerings, but its claims have proved true over time:

> *Sunset Hill is conceded by other cities to be the finest residential property in America. It is priced today from fifty to seventy-five dollars per foot. Yet*

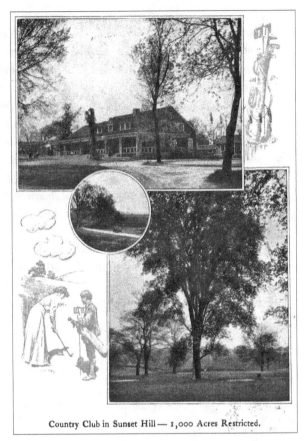

Country Club in Sunset Hill — 1,000 Acres Restricted.

This 1908 postcard advertises the Sunset Hill subdivision and its country club. The reverse side (below) included a preprinted "personal" note from J.C. Nichols, encouraging the recipient to "SEND FOR PLAT." *Author's collection.*

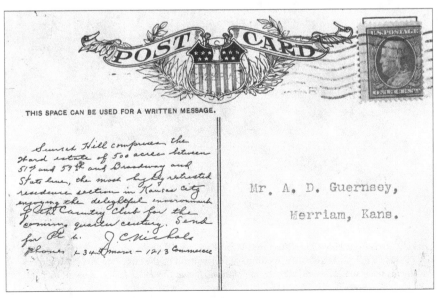

THIS SPACE CAN BE USED FOR A WRITTEN MESSAGE.

Sunset Hill comprises the Hord estate of 500 acres between 51st and 59th and Broadway and State line, the most highly restricted residence section in Kansas City enjoying the delightful environment of the Country Club for the coming quarter century. Send for Plat. J.C. Nichols
Phones + 34 Main — 1213 Commerce

Mr. A. D. Guernsey,

Merriam, Kans.

similar property in all other cities the size of Kansas City brings one hundred to two hundred and fifty dollars per foot. Anchored and protected by the most carefully drawn restrictions known to residential development, SUNSET HILL offers the most assurance to purchasers that the investment not only is safe but will become increasingly valuable. More important still, the things which make living in it delightful today will remain through the years. The wisdom of determining on a location today will be seen instantly. The number is gradually diminishing. A restricted choice is the inevitable result of delay. Families throughout the mid-continent, looking to the future as offering opportunity to enjoy the culture of a great American city, can do nothing so advantageous at this time as select a home site in SUNSET HILL.

The year 1909 was also the one in which Nichols started the political work needed to have the city limits extended southward. Although an annexation measure had been passed by the electorate in 1909, the judicial review process consumed nearly two years before annexation was declared official

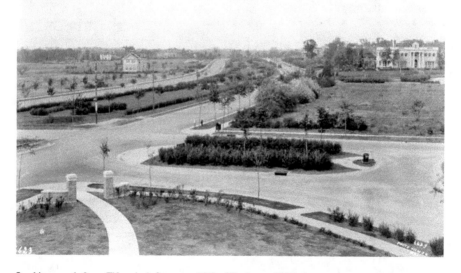

Looking north from Fifty-ninth Street and Ward Parkway, 1920. As a major component of the city's Parks Plan, Ward Parkway was completed well ahead of the large homes that would one day line its sidewalks. *Missouri Valley Special Collections, Kansas City Public Library, Kansas City, MO.*

in 1911. In the interim, as housing was built, the Nichols Company worked independently with the city's police department and with private contractors to make sure the district's first homeowners were safe and secure, the garbage was picked up regularly and the streets and sidewalks were plowed clean from snow in the winter.

Venturing out into the broader world to learn the lessons of other developers proved to be Nichols's other great project in those early years. The company was growing and expanding. The appetite for learning was high. In 1912, Nichols and his most trusted employee, John C. Taylor, made several junkets to see what others had done or were doing in the area of developing, as Nichols called them, "high-class subdivisions." For the most part, the two men learned what not to do. They began at home, with parts of town known in later years as the Old Northeast (near Gladstone and Benton Boulevards) and Hyde Park (near Thirty-ninth Street and Gillham Road). They traveled to America's biggest cities, on the East and West Coasts,

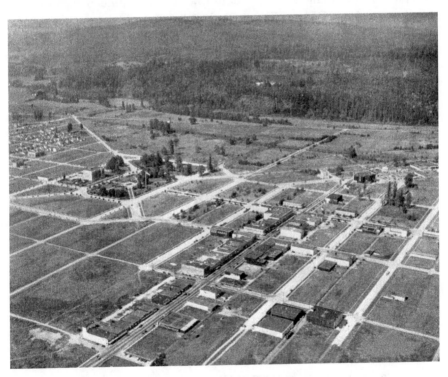

At the request of Kansas City lumber baron R.A. Long, Nichols helped the Long Company design its company town, Longview, Washington, shown in this 1935 aerial. *Author's collection.*

and into the heart of the industrial Midwest. They incorporated what was successful into the district's development scheme. The failures, they vowed to avoid. The results helped to shape the form and function of the Country Club District for years, in most ways for the good—but not all.

In learning from others, Nichols became well known in the real estate and construction industries, and the Country Club District quickly grew to be a national industry model. Between 1919 and 1921, J.C. Nichols worked with local lumber baron R.A. Long on a project in Washington State. Long had purchased a great tract of timber there—one so large that it would require a workforce of fourteen thousand. There was no nearby town that could provide that much labor, so Long determined to build his own town. J.C. Nichols played a primary role in working with Long and local landscape architects Hare & Hare on the design and development of the town that became Longview, Washington.

In the remaining years of this early period, from 1910 to 1918, the Nichols Company was working in all directions toward the continued expansion of the Country Club District. This included the platting of subdivisions like Westwood Park, Wornall Manor, Bowling Green, Hampstead Gardens, Greenway Fields, Country Club District (a separate subdivision that shares the name of the larger Country Club District), Country Club Ridge and Country Club Heights. Even the property that would be most associated with Nichols, the Country Club Plaza, was platted in this early period. But it would be the next era before that project would rise.

1919–1929:
"THE BEST RESIDENTIAL SECTION IN AMERICA"

At the end of World War I, the country entered a period of remarkable growth. For the Nichols Company and the Country Club District, the 1920s would be the golden age, a time of expansion and innovation. The company's confidence in its future was expressed in a September 1919 announcement in the *Country Club District Bulletin*:

> *We have known for several years that the Country Club District, in area, character of development, scientific planning, beauty of homes, community conveniences and harmonious environment, protective restrictions and permanency surpasses any other section in America. We have hesitated to*

use this statement, however, until we were sure it would be substantiated by the leading architects, town planners and landscape engineers throughout the entire country. The consensus of opinion of the best experts from coast to coast, including the president of the National Association of Architects, the American City Planning Institute, Federation of Arts, American Civic Association, and the National Association of Real Estate Exchanges, and particularly our own Mr. George E. Kessler, now so generally agree that the Country Club District of Kansas City is the best residential section in America, that hereafter we intend to carry this statement at the head of each issue of the Bulletin. *We know that every resident of the District realizes its truth, and appreciates the great civic asset he is helping to contribute to Kansas City and its tributary trade territories.*

Because J.C. Nichols was the builder of only a small percentage of the houses constructed in the district, it is difficult to measure the company's growth by the traditional metric of "housing starts." Given the scale of the Country Club District development, a better measure might be the growing size of the district itself. In its earliest promotional materials, the Nichols Company claimed the district was 1,000 acres when it started in earnest around 1910. By 1917, that number had grown to 1,500 acres. In just another five years, in 1922, the Nichols Company maps were showing 2,500 acres of development. By 1930, the claim had risen to 4,000 acres.

Not all acres were equal. In the early years, lot sizes were usually large. The focus then was on showcase homes, but even then there were subtle gradients between subdivisions. The largest homes at that point had been built in Sunset Hill and, on the Kansas side, in Mission Hills. Those grand homes sat on large lots or enjoyed hillside views. The homes east of Wornall Road were typically smaller homes on smaller lots, though still impressive and well beyond the means of an average family of the day. As the Country Club District grew southward, Nichols's approach to subdivision was to continue the trend toward smaller lots as a location for increasingly affordable homes. The pattern did not strictly follow subdivision boundaries, either. The subtlety of dovetailing lots of varying sizes was intentional and one of Nichols's best techniques for maintaining home values. By blurring the distinctions between the housing values on two adjacent blocks, regardless of subdivision lines, the lesser homes retained higher values and newly developed subdivisions had more than one market from which to draw buyers.

Another technique the Nichols Company introduced in this period was the many ways to provide a beautiful landscape in neighborhoods where

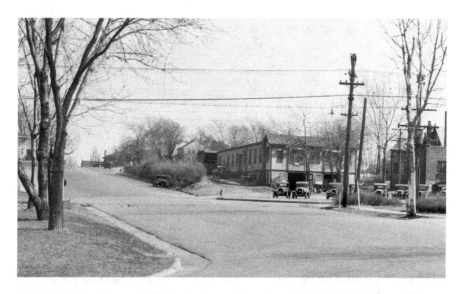

The Nichols Company operated this planning mill just west of Sixty-second Terrace and Main from 1921 to 1949 to craft milled pieces for their housing construction and, later, to provide maintenance services to Brookside tenants. This photo dates to the early 1930s, when the Brookside Taxi Service operated from the building's ground floor. *Wilborn & Associates.*

none had particularly existed before. By incorporating winding streets, creating unusual alignments at intersections, inserting small traffic islands or broad-landscaped medians, or by drawing irregularly shaped lot lines, neighborhoods took on some of the pastoral qualities that had been naturally present in places like Sunset Hill and Mission Hills. Several neighborhoods associated with this era benefited from this approach, including Hampstead Gardens, Stratford Gardens, Suncrest and Crestwood.

While the Nichols Company had to create an aesthetic for some neighborhoods, it was delighted to let the City of Kansas City create that value for it in others. The city's famed parks and boulevard system had grown south with development. Nichols had been working closely with George Kessler, the architect of the city's park system, since the development of Sunset Hill. The Country Club District was directly in the path of the park system expansion, so many of Nichols's development plans were designed to be complemented by that system. In fact, the Country Club District was bounded on all sides by the city's boulevards. On the west and south sides, the wide promenades of Ward Parkway and Meyer Boulevard fit with Nichols's plan for larger, more expensive homes. On the east side, the homes along Brookside Boulevard were more

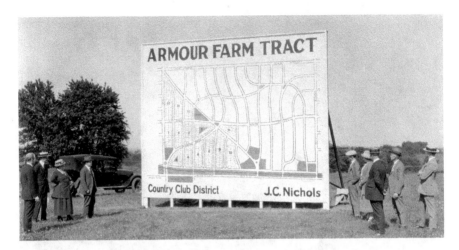

In 1923, the Nichols Company erected this billboard announcing its purchase of a section of the old Armour Hereford Farm to develop as the Armour Hills subdivision. The dark triangle in the left center of the map will one day be Arbor Villa Park. *J.C. Nichols Company Scrapbooks (K0054 b158f1); State Historical Society of Missouri Research Center, Kansas City, MO.*

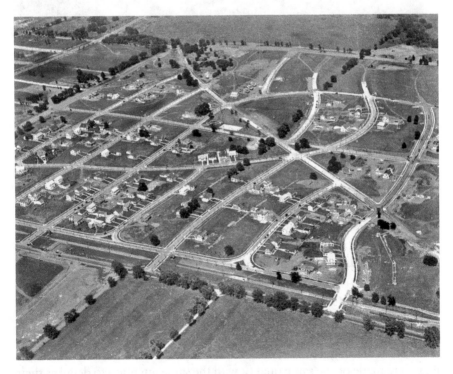

By 1925, two years after the Armour Hills announcement, development was moving at a quick pace. The triangle that is Arbor Park can be seen in the upper center. *Wilborn & Associates.*

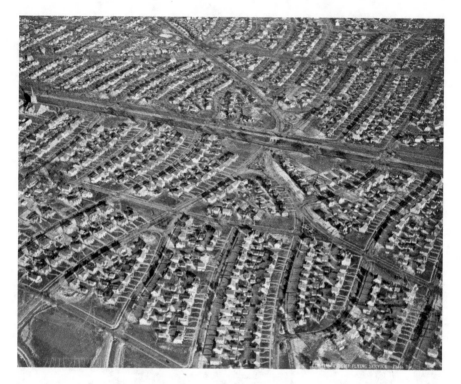

Just five years later, in 1930, both the Armour Hills (top) and Romanelli Gardens (bottom) subdivisions were essentially complete. The Arbor Villa Park triangle is barely visible at the top center. *Missouri Valley Special Collections, Kansas City Public Library, Kansas City, MO.*

modest, but still impressive, and took advantage of the winding nature of the road. Work on the north side boulevards and parks was still in progress, although Mill Creek Parkway on the far northeast had been a part of the system for nearly twenty years.

For all his plans for high-end residences, the 1920s were dominantly the heyday of affordable homebuilding in the Country Club District. During this decade, the Nichols Company began subdividing and developing areas like Armour Hills, Armour Hills Gardens, Armour Fields, Oak Meyer Gardens, Romanelli Gardens and Romanelli West. As each came on line, these neighborhoods filled with the city's burgeoning upwardly mobile but still middle class. Residents were young families starting out, first-generation bootstrappers, occasional immigrants and the newly transplanted. The houses and lots may have been smaller than those in other subdivisions, but they were made of the same quality, with the same attention to detail as their predecessors. And buoyed by all they had heard about these developments,

those who bought these affordable homes were even more eager to become a part of the Country Club District than those who had come before them.

Where it had taken more than a decade to even begin to fill all the Country Club District acreage from Brush Creek south to Meyer Boulevard, in the space of a half dozen years in the 1920s, the Nichols Company filled out virtually all the available space that ran on either side of Wornall Road south from Meyer Boulevard down to Gregory Boulevard. South of there, the Nichols Company ran into other development—the businesses and residential areas that together were becoming known as Waldo. For many years—not until after World War II—the Nichols Company made no investment south of Gregory Boulevard on the Missouri side.

Also during this period, another sort of neighborhood rose up—literally—at the north end of the Country Club District. The Nichols Company started promoting other developers to build and manage apartment buildings. It would need these apartment buildings for the commercial development it was planning.

The Nichols Company had been working on commercial real estate for some time by the early 1920s. Its plans for the Brookside Shops, which opened up in 1919, began as early as 1912, and before that, the Colonial Shops at Fifty-first and Oak Streets were built to support its first subdivision, Bismark Place. But now the company was in the thick of planning its most ambitious commercial project to date: the Country Club Plaza. Nichols's plan for the Plaza was to have a large shopping district on the acres he was acquiring just north of Brush Creek.

If completed as planned, the Country Club Plaza would have the highest concentration of commercial shops, professional offices and entertainment venues in the city outside of downtown. So great was J.C. Nichols's confidence in Kansas City as a growing business center on a national scale that the Nichols Company intended the Country Club Plaza to be not just a significant local and regional commercial destination but a national one as well. That would take years, and Nichols was always prepared to plan far ahead. But until such time as the Country Club Plaza could attract a broader clientele, it would need a surrounding neighborhood to support it. The residents of the Country Club District would constitute part of that patronage, but they wouldn't be enough.

The answer was high-rise apartments. In most major cities, including Kansas City, property values were on the rise at this time, providing an incentive to build to a greater density of housing. But housing density had no place in the core of the Country Club District, where the premium was

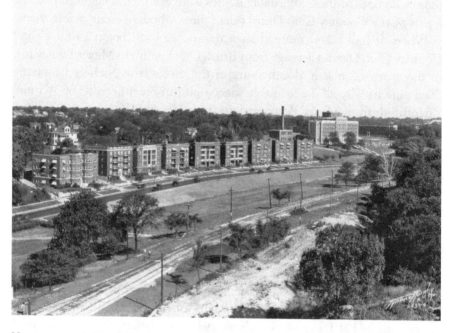

New apartment buildings line the west side of Mill Creek Parkway, connecting the Country Club Plaza to St. Luke's Hospital (far right building), circa 1926. *Wilborn & Associates.*

on homeownership, stable housing values and pastoral settings. Such values are typically at odds with tightly packed apartments. The Country Club Plaza offered an opportunity for high-rise development that didn't compromise the rest of the district. Situated on the very northeast edge of the Country Club District, the apartments were buffered from most of the single-family housing. The Plaza site would also be wedged into property adjacent to the old town of Westport, which had been a commercial hub for one hundred years. It was the perfect place for the district's new apartment buildings.

The Nichols Company did not construct or, as a rule, manage multifamily residential buildings, although during this period it did plat, and eventually build, the Oak Meyer Gardens neighborhood, which included a cluster of duplex housing. The duplexes were constructed to appear as large single-family residences in the same mix of European-style architecture used throughout the rest of the district. Only upon closer examination is it apparent that there are two entrances and often two side porches. Like the bungalows that would become the signature home style of the adjacent

The Country Club District Neighborhoods

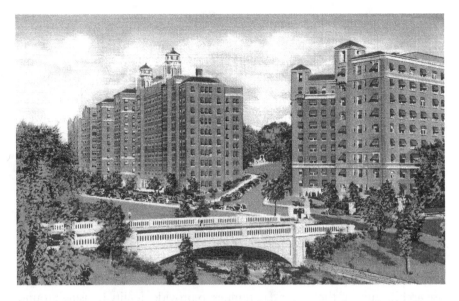

This 1930s postcard shows the stately apartment buildings that grace the south side of the Country Club Plaza in the Nichols Loma Linda subdivision. On the right is the Villa Serena (now the Raphael Hotel). Included in the grouping on the left are the Locarno and the Riviera. *Author's collection.*

Armour Hills neighborhoods, the duplexes offered another entryway into Country Club District residence for families of more modest incomes.

But in terms of creating high-rise apartment buildings for the Country Club Plaza, the Nichols Company worked with others who specialized in those types of development. And like every project within the Country Club District, the Nichols Company guided the character, the design and the legal details of the development. The building sites were predetermined by the Nichols Company for specific reasons related to traffic access and visibility. Building styles needed to complement the architecture of the Plaza and offer residents good views of the creek-side landscape. The properties were generally expected to conform to the same types of deed restrictions, just as the apartment tenants were expected to take part in the district life and adhere to its not-so-subtle principles on behavior, citizenship and good tenancy.

The buildings that resulted from those efforts are some of the Plaza's favorite structures. They sit in clusters at the edges of the district. At the southeast corner of the Country Club Plaza, across Brush Creek in Loma Linda—a Nichols-platted subdivision specifically for high-rises—were the Villa Serena, the Casa Loma, the Biarritz and the Riviera. The Villa Serena would one day become the Raphael Hotel. To the east down Forty-seventh

49

Street between the Plaza and the Nelson-Atkins Museum of Art, apartment buildings line both sides of the road. The Sophian Plaza at the far east end towers over the others, while the Ponce de Leon on Main Street catches the eye with its ornate Spanish detail at the penthouse level. North of the Plaza, small apartment buildings have sat next to St. Luke's Hospital and overlooked Mill Creek Parkway since the 1920s, but the Park Lane Apartments were the largest and most impressive. Finally, the Plaza's west end is home to a quaint collection of apartment buildings known as the "Poets' District," for the literary and artistic names of many of the buildings, specifically Robert Louis Stevenson, Washington Irving, Eugene Fields, James Russell Lowell, Thomas Carlyle, Henry Wadsworth Longfellow, Mark Twain, Robert Browning and artists Henri Rousseau and Paul Cezanne. Several of the Poets' District buildings were designed by noted Kansas City architect Nelle Nichols Peters.

Each of the surviving structures serves as a wonderful example of high-rise architecture of the day and continues to provide quality housing around

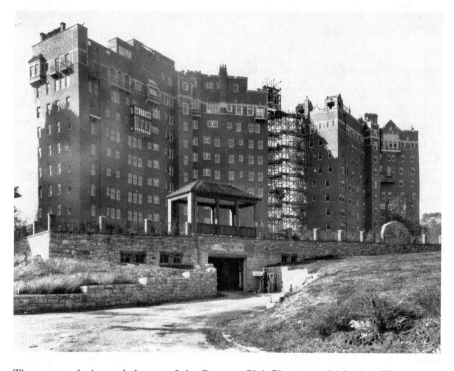

The most exclusive and elegant of the Country Club Plaza–area high-rises, The Walnuts is shown under construction in 1928, seen from the north side garage entrance. *Wilborn & Associates.*

the Country Club Plaza. But the finest example of the high-rise development in the Country Club District has always been The Walnuts, a cluster of three buildings perched prominently above the Plaza on a wooded ten-acre expanse adjacent to Loose Park.

Developed in 1929 and completed in 1930 by the C.O. Jones Building Company of Kansas City, The Walnuts was designed by the Kansas City architectural firm of Boillot & Lauck. As its original sales brochure touted, The Walnuts was "cast in the aristocratic lines of English Manor architecture in homelike accord with its spacious wooded ground setting." And indeed, The Walnuts was designed in a beautiful setting of walnut trees on the highest point on the south side of Brush Creek. But it was the building's interior designs that made it so exceptional. For The Walnuts was not a typical apartment building; rather, it was one where the tenants owned their units. Though they were still referred to as apartments, in later parlance they would be called condominiums. Those who purchased units at The Walnuts were offered their choice of the finest finish materials available: real mahogany or American walnut woodwork, quarter-sawed oak flooring and mosaic marble. Amenities included a formal landscaped garden behind the units, private entrances and an underground parking garage. A complete staff was available twenty-four hours a day to care for communal needs, including in-house mechanics for repair of occupants' vehicles. Each of The Walnuts' three buildings had two wings and eleven floors, for a total of twenty-two units per building. However, new buyers were encouraged to consider buying both units on a single floor, or combining two units directly above and beneath each other, to expand their space. Over the years, The Walnuts has continued to be home to some of Kansas City's most prominent and wealthy citizens and, at times, some of its most reclusive. Among the notables who have lived here is former ambassador to Great Britain Charles Price, who included among his houseguests former president Ronald Regan and his wife, British prime minister Margaret Thatcher and His Royal Highness Charles, Prince of Wales.

The national trend toward high-rise housing appeared in the early to mid-1920s, but it took until the end of the 1920s for the Country Club Plaza high-rises to finish construction. Nearly all were built between 1927 and 1930. Development was becoming more difficult in the late 1920s. In the pages of the *Country Club District Bulletin*, there were signs that the company began to see what was coming as early as 1923, though even Nichols could not have foreseen the full force of what the Crash of 1929 would mean to the homebuilding industry.

In 1923, the company acquired the last track of the old Armour Farm south of Sixty-seventh Street between Wornall Road and State Line. It had been acquiring the old Hereford operation of the famous Armour meatpacking family dynasty for years and had turned those acres of pasture into some of the Country Club District's most popular neighborhoods, including Armour Hills and Armour Fields. The Nichols Company operated on the practice that good development is based on good planning, and good planning starts years, sometimes decades, before the first shovel of dirt is turned. That foresight prompted the purchase of the final acreage of the Armour Farm. In that same *Bulletin* article, the Nichols Company claimed, "It is realized by the developers that this immense tract is not a present-day necessity—but rather a provision for Kansas City in safeguarding the future development of the Country Club District." But in seven short years, the neighborhood that became known as Romanelli Gardens was fully developed, a physical example of the astonishing pace of the housing boom.

The Nichols Company's penchant for long-range planning also meant that, to varying degrees, there were projects lined up for which financial backing and company resources had already been committed and, in a few cases, too deeply committed to simply stop them. In 1929, just a few months before the stock market plummeted, the Nichols Company finished the Romanelli Shops at Gregory Boulevard (Seventy-first Street) and Wornall Road. It was effectively their last new commercial development in Missouri. The company had planned for the Armour Center shops in the Armour Hills neighborhood, but those were never built. No doubt, other less-developed ideas were also delayed or abandoned altogether. Having pushed the boundaries of the Country Club District to the unofficial border of the Waldo area, where development had also been expanding, the future work of the Nichols Company waited to the west, in Kansas.

1930–1950: New Directions

It took a only a few months for the fallout of the October 1929 stock market crash to hit most Americans where they worked and lived. Regardless of how many ways the Nichols Company had tried to secure the property values within the Country Club District, nothing could have protected the district from an economic calamity as profound as the Great Depression. The district's families were all dealing with their own trials. Many lost their

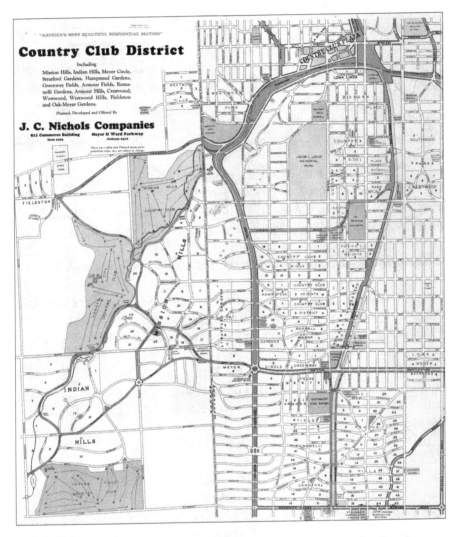

Country Club District map, 1920. By now, Nichols's development plans extend south to Gregory Boulevard. After the Depression struck in 1929, the district would not expand much beyond these boundaries until the 1940s. *Missouri Valley Special Collections, Kansas City Public Library, Kansas City, MO.*

homes during this period, and there were whispers about some families taking in boarders or running small businesses out of their homes. There was no household budget for some of the niceties of Country Club District life like private schools, garden shows and country clubs. The fortunes of the district's residents mirrored those of the Nichols Company, which was trimming costs wherever possible. It no longer printed the *Country Club*

District Bulletin, nor did it sponsor the many children's outings and social activities that had been creating strong bonds between the district's residents for so many years. Homeowners in an unstable economy in neighborhoods suffering for the first time from a lack of resources would have seemed to Nichols unacceptably vulnerable. So the Nichols Company turned most of its energy toward its outlying shopping centers. The shopping centers offered some economic stability that the Nichols Company needed to weather this economic storm.

The Nichols Company opened the first shop in Brookside in 1919. In 1923, the first of the Country Club Plaza shops came on line. In terms of Nichols's complete vision for them, both were still incomplete in 1930. As residential development all but stopped, the Nichols Company used the 1930s to continue investing in its commercial properties. The last set of retail shops in Brookside, the block between Brookside Boulevard and Wornall Road, was completed in 1936. The commercial areas of Brookside that never belonged to the Nichols Company, south of Sixty-third Street between Main Street and Wornall Road, were largely developed in the 1930s and 1940s by individual developers. The Nichols Company also continued its investment in the Country Club Plaza during this period. Some who had been forced from homeownership migrated to the Plaza, into the high-rise apartment buildings built in the late 1920s. The Nichols Company also relocated its offices from downtown to the Plaza, forever making the Country Club Plaza the flagship development of the Nichols Company.

In 1931, the company opened a rental department for the first time. Rentals provided two sources of income. First, as sometime mortgage holders on houses built in the Country Club District (primarily those where the Nichols Company had also served as builder), the Nichols Company found itself having to foreclose on a higher number of mortgages during the Depression. Through the new department, those houses could be made available to renters. Similarly, while the Nichols Company did not own or operate any of the Plaza-area apartment buildings, the company's rental department helped the high-rise owners keep their units occupied. Occupied units were essential to maintaining good sales at Country Club Plaza shops, and those sales were at the core of the rents on which the Nichols Company relied so heavily during the 1930s.

Even though commercial development was largely sustaining the company during this period, the Country Club District residential development continued—although slowly. Armour Hills Gardens was platted in 1930, and along with Oak Meyer Gardens to its north, it established the far eastern

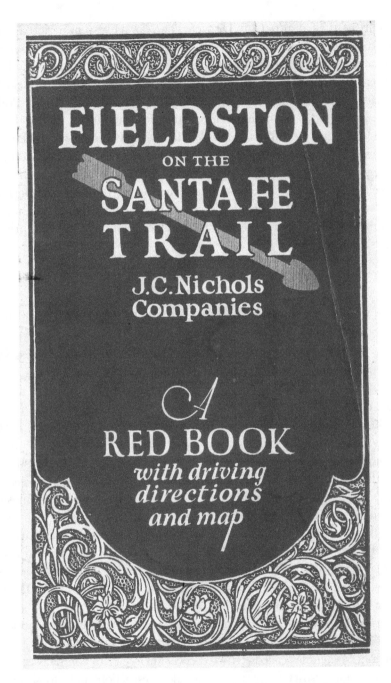

Auto tour brochures and maps were another favorite promotional tool of the J.C. Nichols Company. This 1930 "Red Book" is for the Fieldston subdivision in Kansas. *Author's collection.*

boundary of the Country Club District. Then, for a five-year period, no new residential subdivisions were platted. Starting in 1935, the Nichols Company reactivated development on the Kansas side, starting with Sagamore Hills, and then in quick succession Mission Woods (1937), Fairway (1938), Fieldston Hill (1940) and the large area that represents various modern-day Prairie Village subdivisions, including Prairie Hills, Prairie Village, Prairie Fields, Prairie Ridge and Corinth Hills (1941). Finally, the company returned to the Missouri side to work on Romanelli West, west of Ward Parkway and north of Gregory Boulevard. This neighborhood, platted in 1946, was the final undeveloped piece of the old Armour Farm tract, the last neighborhood to be recognized by J.C. Nichols himself as part of the original plan for the Country Club District and the last residential development initiated prior to Nichols's death in 1950.

Deed Restrictions in the Country Club District

If J.C. Nichols had but one talent that contributed to his success as a developer, it was his ability to synthesize his own experiences and those of other developers into an ever-evolving but centrally consistent model. By the end of his career, the Nichols model was really a course on "how to"—how to build and sell houses, how to design beautiful homes that last, how to fill shopping districts with tenants. These models were eventually codified in the book J.C. Nichols produced as founder of the prestigious Urban Land Institute in 1947, near the end of his career. *The Community Builders Handbook*, still in print today, seems charmingly dated in style and language, but modern developers still adhere to many of its basic principles, a testament to how well the Nichols Company's practices have stood the test of time. Few of these practices were wholly inventions of Nichols' ingenuity; rather, he took the practices that had predated him, adjusted them for the specific circumstances of the Country Club District and fine-tuned them over time.

So it was with the deed restrictions that served as Nichols's foundation for protecting the long-term value of the Country Club District property. Deed restrictions, sometimes called restricted covenants, refer to contracts covering conditions that restrict property use or sale. Restrictions date to sixteenth-century English common law, and their use continues to the present. At their core, restrictions are defined by two general characteristics. First, the

Shown in a 1950s postcard, this row of houses in Romanelli West, just west of Sixty-ninth Street, was often used in Nichols's marketing materials. It reflected many of Nichols's development ideals—quality housing conforming to uniform design standards in a beautiful setting. *Author's collection.*

restrictions must be made explicit, as in a contract. The restrictions must also have an intrinsic connection to the property, known as "running with the land." Requiring that a piece of land may not be used for industrial activity is a compelling connection, whereas requiring that the purchaser of the property provide the seller a personal service would not be a valid connection.

Generally, contemporary deed restrictions cover issues of the scale and placement of buildings, the nature of the architecture or building materials, where easements are located on lots and similar issues of construction. Starting sometime after the Civil War, and most likely at the time of the famed *Plessy v. Ferguson* case of 1896 that sanctioned institutionalized racial discrimination, deed restrictions started excluding sales to individuals based on the buyer's race.

Nichols was not the first to use deed restrictions in Kansas City. That distinction is generally assigned to Kersey Coates, who used them in the 1850s in his development of the areas around Quality Hill just west of downtown Kansas City. Coates's restrictions included a provision that all buildings would be constructed of brick. This is an example of how restrictions came to be about both security and aesthetics. Rapid expansion in the West had generated new cities where buildings were often of wood-

frame construction, in a time when fire protection was difficult and fire hazards were everywhere. Brick construction provided some assurances, but it also created development where the houses shared a common style and a distinctive character, adding to their attractiveness as investments.

J.C. Nichols started grappling with the issue of deed restrictions in his first project, Bismark Place. There, the restrictions had already been defined by the parties who had purchased and subdivided the property before he bought it for development. Starting there, and continuing through the entire Country Club District development, Nichols adjusted the restrictions, mostly in terms of their duration and their method of renewal. He made individual adjustments for each subdivision on matters like lot size or architectural character and the like. While he faced some opposition to the restrictions from those who thought that curtailing property owners' "fair use" would deter buyers, Nichols felt that locking each subdivision into its own set of restrictions was essential for protecting the long-term value of property in the Country Club District.

In 1908, when Nichols undertook the second district subdivision project, the Country Side Extension, the term of the deed restrictions was stretched from ten to twenty years. In addition, this was the first subdivision where Nichols applied one set of restrictions for the whole subdivision at the time of platting, avoiding inconsistencies created when the restrictions were applied on a lot-by-lot basis. The Country Side Extension became Nichols's initial model, a model that included clauses requiring development to be single-family housing with a minimum construction cost of $5,000; defined the orientation of the house to the street and the length of setbacks; determined that utility easements run along the rear of the lots; and prohibited subsequent sale of the property to blacks ("Negroes," as stated in the restrictions). The racial clause was a common one of the time; it had been included in the restrictions Nichols inherited with the Bismark Place properties, and he carried it forward.

A year later, as Nichols was working on the Sunset Hill and Rockhill Place developments, the restrictions related to construction were essentially the same as those at Country Side Extension. The minimum cost of housing construction was the primary restriction that continually changed from subdivision to subdivision—in Sunset Hill, for example, it was $10,000—but now the term was extended to twenty-five years. Midway through the Rockhill Place project, a condition was added about renewal of the restrictions. When the twenty-five years had passed, the restrictions could be renewed by a majority vote of the property owners.

Nichols used the concept of "frontage foot" to apportion what majority meant—another of his innovations.

It wasn't until 1914 that Nichols finally devised what he considered to be a satisfactory way to deal with the duration question, an approach that was ultimately adopted by most developers of his day and almost everyone since. From that point forward, Country Club District deed restrictions would be automatically renewed unless the same majority of homeowners (by frontage foot) organized to either revise or revoke any or all of the restrictions. By shifting the effort required by homeowners from those who simply wanted to maintain the status quo to those who wanted to revise the deed restrictions, the Nichols Company all but ensured that in the future, changes to or elimination of deed restrictions in district neighborhoods would be the exception rather than the rule.

For another ten years, the Nichols Company tinkered at the margins with the language of deed restrictions. In 1924, the Nichols legal team revised all preceding deed restrictions, making them uniform with the company's current standards. It was a time-consuming and expensive proposition. The company had to lobby each individual neighborhood separately, including some adjacent neighborhoods that had not been developed by Nichols but had eagerly signed on to the company's deed restrictions in the hope of enjoying the same property protections. The process took J.C. and his men to countless homes association meetings. When an individual homeowner resisted the change, the Nichols Company would often have to purchase that property. In the end, the restrictions were made uniform throughout the district.

Nichols may have done all he could to ensure that the restrictions were in place, but there were social forces at work, even in the early days of the district, to eliminate them. Across the country, states were empowering the new zoning laws of their cities. Many of these laws sought to sanction racial discrimination as part of zoning. In 1917, the United States Supreme Court ruled against these particular racial restrictions, saying that states could not discriminate, based on the equal protection language of the Fourteenth Amendment to the Constitution. But in 1925, the Supreme Court also ruled that the Fourteenth Amendment did not apply to contracts between individuals and that, ultimately, that contract is the instrument to determine how property is sold and used.

The landmark ruling on racial discrimination in real estate contracts did not come until 1948, with *Shelley v. Kraemer*. The Shelleys, an African American family in St. Louis, Missouri, had purchased property without realizing it held racial restrictions. The plaintiff, Louis Kraemer, owned

subscribed to this contract shall be and are hereby restricted as fol-
lows, towit:

Any residence erected on Lots 1,25,26,27 and ,28 shall cost
not less than $3000.00, and any residence erected on Lots 72 to 79 both
inclusive, shall cost not less than $4000.00.

Any residence erected on any of the other lots specifically
set forth below, shall cost not less than $5000.00.

None of said lots shall be conveyed to, used, owned, nor
occupied by negroes as owners or tenants.

Acting in accordance with the terms of the declaration of re-

This excerpt of a 1921 deed for a Westwood home shows the typical language of the race restrictions used by developers of the day, including the Nichols Company. *Mary Bunten and Norm Friedman.*

property some distance from the Shelleys. The Missouri Supreme Court had originally ruled in favor of Kraemer, but when the case came before the U.S. Supreme Court, the finding was for the Shelleys—though not, perhaps, for the reasons one might image. The Supreme Court ruling was not about the Shelleys' constitutional protection from discrimination. The high court's ruling stated that, for the same Fourteenth Amendment reasons that prevented states from discriminating, courts could not enforce discriminatory contracts. Therefore, the courts could not, and forever more would not, be a vehicle for enforcement of contracts with racial restrictions. The ruling certainly did not prevent racial discrimination in housing, but it did help to drive it into the shadows. The courts still did not have a basis for declaring those restrictions unconstitutional. Those issues would not be addressed until the Civil Rights Act of 1964.

At the same time, racial restrictions were not the only ones in play. In some areas of the country, discriminatory restrictions included not only blacks but also Asians, Jews, Catholics and other ethnic groups depending on different geographies and local prejudices. But it was well known that Nichols and others in his group of high-end developers around the country did not sell to Jews. Research on J.C. Nichols and the Nichols Company has not uncovered any reason for this prejudice aside from the tendency to follow the industry norms and the conventions of the day—the market, accustomed as it was to such protections, would never have invested in the Country Club District without those racial restrictions in play. But there is evidence of Nichols's personal struggles with the question of selling property to Jews.

Between 1917 and 1919, J.C. Nichols attended a regular gathering of his industry colleagues known as the Annual High Class Developers Conference. The proceedings of those meetings were recorded, and their candid nature speaks to the understanding of the participants that their conversations were held in strict confidence with no threat of their comments being shared. Copies of these proceedings are archived with the Olin Research Library at Cornell University in New York. As a result of research by prior authors, most notably the extensive research of Dr. William S. Worley and his 1990 publication, *J.C. Nichols and the Shaping of Kansas City*, some summaries of those proceedings are available. In his work, Worley describes Nichols's own conflicted feelings regarding selling to Jews. While not a part of the formal deed restrictions, Nichols admitted to the group of developers that while it was a Nichols Company policy not to sell to Jews, several Jewish families had purchased

The Nichols Company rarely included its race restrictions in its publicity; this 1930s era "Fact Book" is a rare exception. *J.C. Nichols Company Records (K0106b172f10); State Historical Society of Missouri Research Center, Kansas City, MO.*

land in the Country Club District from other real estate companies. Nichols confessed to his colleagues that he had received a proper dressing down by a prominent Kansas Citian who was also a Jew. The man pointed out several truths about the impact of this discrimination on the fiber of the broader community, facts that clearly confounded some of Nichols's long-held beliefs about community building. Eventually, Nichols sent out a written statement to

of ground than the required frontage, and the provisions for reducing such frontage shall apply with the same force and effect to outbuildings as to the residence to which such outbuildings are appurtenant.

Section 10. Ownership by Negroes Prohibited
"Repealed by Board of Directors on Oct 14, 2005,
under and pursuant to Senate Bill 168, 93rd General
Assembly, 2005, signed by the Governor of the State of
Missouri on July 12, 2005, and codified as Sec. 213. 041
RSMo.2000.as amended 2005."

Section 11.

Billboards Prohibited

No signs, advertisements, billboards, or advertising structures of any kind may be erected or maintained on any of the lots hereby restricted without the consent in writing of The J. C. Nichols Investment Company; provided,

Though no longer applicable, race-restrictive language remained in many of the district's Home Association bylaws until 2005, when Missouri legislation made redaction possible. *Oak-Meyer Garden Homes Association.*

his fellow developers that said, in part, "We [in Kansas City] have some fine Jewish families…and some of them are good friends of mine on the different charitable institutions…[P]ersonally, it is getting very much under my skin, by George, it is so un-American and undemocratic, and so unfair to exclude a man on account of his nationality, regardless of what he is himself."

While by contemporary standards, Nichols's position seems a half measure, at the time it had a dramatic impact on his reputation among his colleagues. Had Nichols not enjoyed such a leadership position within the group, and had the Nichols Company not demonstrated such profound, indisputable success by any industry measures, the effects on Nichols's reputation might have been more drastic.

The racial restrictions were legally nullified in the 1960s, but they remained in the paperwork of the various Country Club District Homes Associations. That changed in January 2006, when a new Missouri statute went into effect. Tucked neatly at the beginning of Senate Bill 168 of the Ninety-third General Assembly, a bill that dealt predominantly with the resolution of disputes concerning alleged defective residential construction, was language about those racial clauses. Homes associations were facing the threat of lawsuits from those who felt that even the mere presence of the offending language in their deeds was a discriminatory act. Therefore, in response to the associations' requests, the bill required homes associations to eliminate from their governing documents any restriction clause that violates Missouri's fair housing laws, including the remnant racial discrimination clauses from the Nichols-era deed restrictions.

CHRONOLOGY OF DEVELOPMENT

A shelter for the streetcar line sits near the trestle between the Armour Hills and Romanelli West neighborhoods, circa 1920s. *Missouri Valley Special Collections, Kansas City Public Library, Kansas City, MO.*

Unless stated otherwise, the chronology below indicates by year when various Country Club District subdivisions were platted. A few additional milestones of the Country Club District's development are also included.

1905	Bismark Place.
1907	Rockhill Place, Rockhill Park and Rockhill Park Extension.
1908	Country Side and Country Side Extension. Also that year, J.C. Nichols first established his own real estate company and began using the term "Country Club District" in his sales promotions.
1909	Rockhill Heights and Sunset Hill.
1910	Country Club Ridge and Wornall Homestead. The Wornall Homestead property included the first piece of what would become the Brookside Shops area.
1911	Bowling Green, Country Club Heights and Country Club Plaza. The city's annexation of the Country Club District property, begun two years earlier but challenged in court, was also completed, and city limits in this part of town were extended from Forty-ninth Street to Seventy-seventh Street.
1912	Country Club District (a subdivision within the larger district) and Mission Hills.
1913	Westwood Park and Wornall Manor.
1914	South Country Side.
1917	Hampstead Gardens and Greenway Fields.
1919	Construction of the Brookside Shops began.
1920	First Crestwood subdivision lots were offered.
1921	The Nichols Company purchased Westwood Park, just west of the Country Club Plaza area, from developer L.R. Wright. Wright started in 1913 with only the barest of restrictions. Sales in Nichols's first year exceed Wright's sales in the entire previous eight.
1922	Suncrest, Armour Hills and Stratford Gardens.
1923	Armour Fields. Also this year, the first building of the Country Club Plaza was occupied.
1925	Romanelli Gardens and Indian Hills. Planning for the Romanelli Shops began.

1926	Meyer Circle and Fieldston.
1927	Loma Linda and Oak Meyer Gardens.
1930	Armour Hills Gardens.
1935	Sagamore Hills.
1937	Mission Woods (Kansas).
1938	Fairway (Kansas).
1940	Fieldston Hill (Kansas).
1941	Prairie Village subdivisions, which eventually would include Prairie Hills, Prairie Village, Prairie Fields, Prairie Ridge and Corinth Hills (Kansas).
1946	Romanelli West. This was the last of the subdivisions recognized by J.C. Nichols as part of the Country Club District and the last development initiated before Nichols's death in 1950.

CHAPTER 3

THE FEATURES
OF COMMUNITY

Community features may be the cause of your owners becoming permanent residents...the inspiration that causes a better and more intensive development of every private lawn; an inspiration for better architecture; for better interior decoration—and the cause of the development of a greater interest and love for one's home...the cause for closer friendships, and a greater neighborhood and community spirit...and in the end, from it all comes a greater love and patriotism for city and nation in the hearts of both young and old.
—*J.C. Nichols in a speech to Washington, D.C. realtors, "Suburban Sub-Divisions with Community Features," June 1924*

Nichols's vision for the Country Club District was fixed on more than its expanding horizon. The vertical features, the spine that ties a community together, needed to be there, too, if Nichols's "plan for permanence" was to have a chance. So early on, as the built features of the district took shape, the Nichols Company worked on other projects—what Nichols referred to in his writings as "community features."

In a 1924 speech in Washington, D.C., Nichols introduced the idea of community features to his audience of realtors when his thinking was still in its formative stages. Nichols talked both broadly and specifically on the subject. Broadly, community features were anything that served the dual purposes of increasing the quality of residents' lives and strengthening the value of the homeowners' investments. On Nichols's list, that included schools and churches, city infrastructure and public services, social organizations and

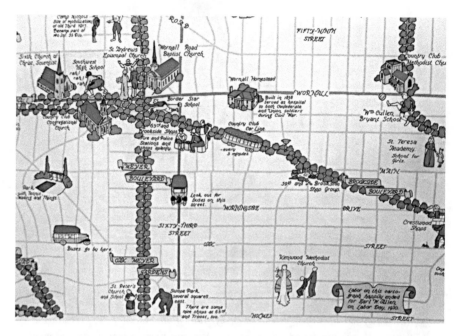

A detail of a cartographic mural of the Country Club District showing the Brookside area. The map graced the lobby of the company's new headquarters in 1930. Earl Allen, a Nichols Company architect (and, later, son-in-law to J.C. Nichols) was the mural's artist. *Author's collection.*

homes associations. Specifically, Nichols had plenty of examples, which he urged the attending realtors to adjust for their individual circumstances. On that list, Nichols cited, among other ideas, a community field day, bicycle clubs, hiking trails, horseback riding, flower shows and public art. The Country Club District had all those community features and many more. Nichols and his staff members observed, asked, borrowed and refined every technique they could find from peers and by listening to the voices of residents. Many ideas were tried; some had staying power and others did not.

Much of Nichols's energy went to building community at a broader level. He was a central figure in promoting and then building the University of Kansas City, now the University of Missouri–Kansas City. The Kansas City Art Institute predated Nichols, but he served as board president during the 1920s, when it was elevated from a small, struggling school to a nationally recognized center for the visual arts with its own campus near the Nelson-Atkins Museum of Art. He served in a number of civic positions locally and in a few nationally, all of which fueled his thinking about possible improvements to Kansas City's economic and social life.

But that was for the broader community. For his primary interest—the Country Club District—he likely had more ideas than could be reasonably managed by the company. Just as Nichols had predicted, as development moved on, the responsibility of managing each subdivision's deed restrictions was now falling to those neighborhoods. Likewise, the company needed to find help in building community, in supporting all these community features it planned. The neighborhoods were obvious partners in that effort as well, but by the early 1920s, there were so many neighborhoods that communication and coordination among them was becoming more difficult.

The Homes Associations of the Country Club District

In 1897, the City of Kansas City annexed the old frontier town of Westport, extending the city boundaries to just short of the northern edge of the Country Club District. Even as he started working in Bismark Place, J.C. Nichols made extending that border a goal. In 1909, voters passed a measure that extended the limits to about Seventy-seventh Street in the Waldo neighborhood, just beyond the southern edge of current Nichols Company plans. Disputes in the court system kept the change from going into effect until 1911. By that time, the Nichols Company had been developing home sites for six years with virtually no city services to support them. Even with annexation, the City of Kansas City was hard pressed to extend those services at a pace that matched the Nichols Company's speed of development.

In the beginning, Nichols worked with the city to extend some of those services. They established a satellite police station in the clubhouse of the Kansas City Country Club near Fifty-first Street and Wornall Road. At about the same time, Nichols gave to the city property along Sixty-third Street for construction of a state-of-the-art combined police and fire station. But there were still other services residents would need—garbage collection, street repair and snow removal among them.

The public service dilemma was more fundamental when the Nichols Company crossed the border into Kansas to develop Mission Hills in 1914. There was no Kansas equivalent of Kansas City, Missouri, by which the Mission Hills property could be annexed. The nearest incorporated town was Merriam, five miles away and too far for annexation. Mission Hills (which did not legally incorporate until 1949) would need a different approach.

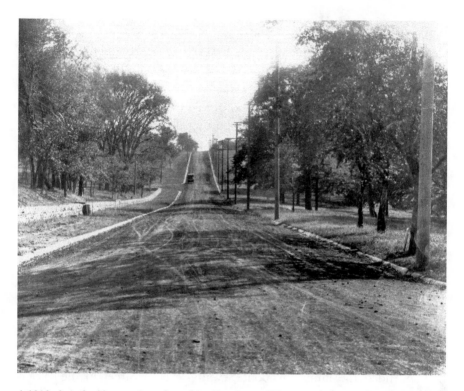

A 1912 photo looking south on State Line Road near Fifty-seventh Street. Unpaved streets were just one of the matters facing the newly formed Mission Hills Homes Association, the first in the district. *Wilborn & Associates.*

This prompted the Nichols Company to create the Mission Hills Homes Company, the first of more than two dozen such associations organized for Country Club District neighborhoods.

The charter for the Mission Hills Homes Company provided for all the services normally performed by a city. The homes company was managed by a board of directors. The board contracted services for infrastructure improvements, maintaining vacant lots and public areas, managing arrangements for sanitation and utility services and, perhaps most importantly, enforcing the subdivision's deed restrictions. Individual property owners paid a basic assessment, and the Mission Hills Homes Company had the right to increase the rate.

Once there were a handful of these homes companies—or homes associations, as most were called—the Nichols Company decided to make them autonomous by establishing the J.C. Nichols Homes Associations, consisting of the presidents of each homes association, meeting on a

monthly basis. The autonomy would have served both sides. It gave the neighborhoods self-governance and buffered the Nichols Company from conflict-of-interest issues.

Physically, the autonomy was barely at arm's length. The office of the Homes Associations was in the Nichols Company's offices, staffed by one of its long-term employees. In 1923, after a decade working at the switchboard of the J.C. Nichols Company, Faye Duncan (now Faye Duncan Littleton) accepted the company's offer to become the secretary to the group, a position she held for nearly thirty years. Among Faye's other duties, she coordinated the monthly meetings, which included a driving tour of the entire district. Faye and the association presidents looked for problems with individual homes, public infrastructure or Nichols Company properties and discussed solutions. The goal was to use the associations' collective influence to help resolve matters while achieving J.C. Nichols's goal of ensuring that Country Club District standards were continually met.

The Mission Hills Homes Company became a model for moving forward, and like all J.C. Nichols's strategies, it was continually revised. The Country Club District Homes Association (serving the smaller subdivision that shares the district's name) formed in 1921 as the first Missouri-side group.

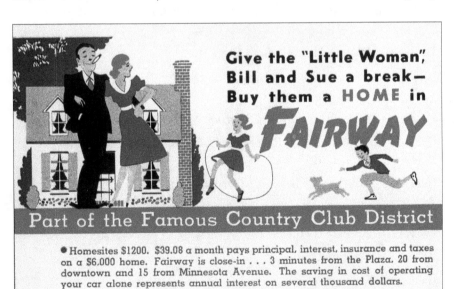

Give the "Little Woman", Bill and Sue a break— Buy them a HOME in

FAIRWAY

Part of the Famous Country Club District

● Homesites $1200. $39.08 a month pays principal, interest, insurance and taxes on a $6,000 home. Fairway is close-in . . . 3 minutes from the Plaza, 20 from downtown and 15 from Minnesota Avenue. The saving in cost of operating your car alone represents annual interest on several thousand dollars.

Fairway, in Kansas, became a Nichols Company development in 1938. By the early 1940s, the company was advertising it as conveniently located to all parts of town. *J.C. Nichols Company Scrapbooks (K0054 v14p136); State Historical Society of Missouri Research Center, Kansas City, MO.*

During the 1920s, when housing construction was at its height, the Nichols Company formed fourteen associations. In a 1937 speech, Nichols mentions having fifteen, an indication of the rate at which housing construction had declined during the Depression. In all, there were about eighteen to twenty associations formed during Nichols's lifetime.

Interestingly, Nichols was never able to form a homes association for the Sunset Hill subdivision, despite the fact that he moved into that neighborhood in 1920. Unlike many of the other subdivisions, Nichols had never owned the Sunset Hill property. He had developed the land for its owner, Hugh Ward, with whom Nichols worked successfully. But Ward died young in 1909, just as Nichols was getting started, and Nichols's relationship with Ward's widow was not as amiable.

Those homes associations organized prior to 1950 are listed here, in order of their incorporation. By Nichols's death in 1950, some of the Kansas-side areas covered by Nichols Company homes associations already had, or would soon, become independent communities. Since 1950, several other homes associations combined or took different names. For these reasons, the following list is meant to be neither comprehensive nor consistent with today's neighborhood association names or boundaries, but it does provide a glimpse into the history of the district's contemporary neighborhood associations:

1914	Mission Hills Homes Company
1922	Armour Hills, Country Club District (separate subdivision within the larger district)
1924	Wornall Homestead, Wornall Manor, Country Club Ridge
1926	Armour Fields, Romanelli Gardens, Stratford Gardens, Westwood Hills
1927	Fieldston, Oak Meyer Gardens
1932	Indian Hills
1934	Westwood Hills
1937	Tomahawk Road
1938	Fairway
1942	Mission Woods
1947	Prairie Village

THE *COUNTRY CLUB DISTRICT BULLETIN*

Through the homes associations, the Nichols Company provided the foundation for community: representative governance, provision of basic services, oversight and regulation. The homes associations also created a barrier between Nichols and the homeowner. Nichols wanted to reach the residents directly. Building his community, Nichols had many ideas for projects and events. He needed a way to keep families up-to-date on all the company was doing or had in the works. He wanted the chance to influence their habits as homeowners, residents and shoppers. So J.C. Nichols devised another tool that was, during the 1920s, a record of life in the Country Club District: the *Country Club District Bulletin*. When the first issue arrived, dated April 15, 1919, just below the newsletter's masthead and an article touting, "Right now is the time for tree planting," a small editorial piece appeared under the simple title, "Announcement":

> *In order to serve and develop property interest and create a more ideal community life for the residents of the Country Club District, we have adopted a policy of issuing a monthly bulletin, which will carry no advertising and will be mailed to all owners of property in the Country*

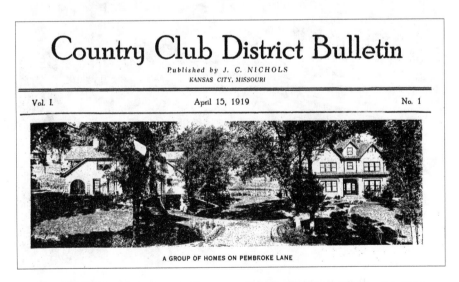

The front page of the inaugural edition of the *Country Club District Bulletin*, April 1, 1919. The *Bulletin* was distributed to all district residents until Depression-era budget cuts forced the Nichols Company to stop publication. *Missouri Valley Special Collections, Kansas City Public Library, Kansas City, MO.*

Club District. This bulletin will take the place of notices we have mailed from time to time, and in order to keep advised of the various services offered and conveniences afforded, you should carefully read each issue. News items of interest, relating to anyone or any event in the Country Club District and any suggestion for its further beautification or the greater comfort of the people living in this section will always be welcome.

J.C. Nichols

J.C. Nichols made the connection to the district personal by putting his name on the announcement and by listing himself—not the company—as publisher of the *Bulletin*. Strong similarities in style and language exist between the tone of the *Bulletin* and Nichols's writings and speeches, suggesting Nichols may have written some of the articles himself, though most likely only in early editions. The articles in the *Bulletin* certainly covered many of Nichols's favorite topics. They were a mix of avuncular testimonies to good homeowner practices, modest reprimands for general misbehaviors and a healthy dose of boosterism for the events in the district, like the opening

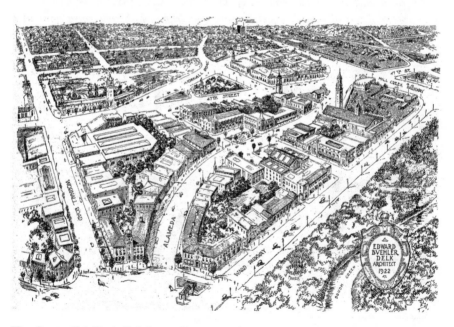

The *Country Club District Bulletin* was the company's preferred vehicle for announcing new projects. The 1923 announcement for the Country Club Plaza included this sketch by its original architect, Edward Buehler Delk. *Missouri Valley Special Collections, Kansas City Public Library, Kansas City, MO.*

of the company's new shops or new subdivisions—in short, anything that promoted the Country Club District and the J.C. Nichols Company.

News within the subdivisions was the central focus of the *Country Club District Bulletin*. The cover story was often the announcement of a new subdivision, detailing the qualities this area would bring to the growing Country Club District family of neighborhoods. Architectural illustrations were another favorite front-page feature, usually accompanied by detailed floor plans and a discussion of the vision of the architect. The *Bulletin* frequently listed the names of both new property owners (as lots were sold) and new residents (as people moved into new or purchased homes). These lists often included the person's name, his or her occupation and, if space permitted, the new address. The more prominent the new resident was, the more likely he or she was to be included on the list. An example is the June 1919 issue, which included among the new residents the name of N.W. Dible, arguably the best-known Kansas City homebuilder of the day after J.C. Nichols. This type of "news" made the *Country Club Bulletin* a great promotional piece for the value of the Country Club District.

The *Bulletin*'s primary purpose, however, was to galvanize district residents into being fully participatory in district life and, as it follows, fully invested in the district's long-term success. Listing a few samples below, the November 1921 article "Do You? Won't You? Please Don't!" was really just a lengthy list of the dos and don'ts to which a Country Club District resident should adhere. The article also sums up the Nichols Company's approach to educating homeowners on the proper way to manage their properties:

> *Do you cultivate and water the trees in the street parking as well as on your lawn?...Won't you, when building a home, request your workmen to burn their lunch papers so they will not litter up the neighborhood?...Please don't pick flowers from the parks throughout the District...Do you forward to the Nichols Companies suggestions to make the Country Club District more beautiful and a greater asset to Kansas City? Please do!*

These instructions were not always stern and directive. The *Bulletin* invariably had a few household tips and some general advice on a number of home-related topics. Gardening was a favorite. The *Bulletin* covered the merits of keeping a vegetable garden ("[C]ertain dividends of health, fun, and the finest of vegetables without price do not mark the limit of profit"), alongside articles that reminded residents that "Springtime is Pruning Time" or techniques on keeping one's lawn green throughout the hot summer.

Gardening became so important in the life of the Country Club District that the Women's Community Council (itself a district-formed organization) planned an annual Flower and Garden Show held in Brookside's Community Hall. The *Bulletin* wrote all about it, of course. Before the show, it urged everyone to enter and promoted it as a community-gathering event, and when it was over, the *Bulletin* announced the winners in all categories, along with photos of the winning entries. The *Bulletin* also printed photos of prominent gardens in the district and encouraged residents to use its pages to share photos of their own lawns and gardens. And while the *Bulletin* proudly announced that it did not accept advertisements, it should be noted that the Nichols Company also maintained a nursery operation for many years that was likely a favorite supplier of many of the district's plantings.

Under the regular heading "Club Notes," the *Country Club District Bulletin* became a source for keeping track of all the social activities within the district. Notices appeared regularly about the formation of tennis clubs, new golf courses and birthday luncheon groups. There were frequent announcements about upcoming talks for the district ladies at monthly luncheons or afternoon teas or invitations to join the Women's Community Council or the board of the Homes Association. Parents were urged to attend upcoming dance recitals, to volunteer as scoutmasters or to serve as homeroom mothers. And just in case the coverage of these opportunities was insufficient to prompt a resident to get involved, the November 1921 issue featured the following short notice, "Have You Found Your Niche?":

> *Two thousand families are living in the Country Club District, where life will be found really worthwhile, according to the measure of neighborliness and community interest shown. Have you found your place in one or more of the various organizations within the District? Write to* [the Community Secretary] *as to how you would best like to express your activity for the community good. Don't put it off. Do it today!*

The *Bulletin* promoted lectures and other events organized by the Nichols Company for the "benefit of our residents." The company's sponsorship of the Ross Crane Lectures is both a classic example of the type of event the Nichols Company believed would be good for its residents and the form of announcement designed to appeal to the new homeowners who were the company's target audience. In the 1920s, Ross Crane served as the head of the Extension Department of the prestigious Art Institute of Chicago, in addition to being a well-touted interior designer of his time. His position with

Community Hall, on the second floor of the original Brookside Building at Sixty-third Street and Brookside Boulevard. Shown here is a dance recital by the students of Helen Thomas, who operated a dance school in the 1920s. *J.C. Nichols Company Scrapbooks (K0054 v5p14); State Historical Society of Missouri Research Center, Kansas City, MO.*

the institute gave him a chance to create a traveling show on home design. He toured the country during the early to mid-1920s providing instruction to the contemporary housewife on a wide range of home-decorating tips. In its April 1921 issue, the *Bulletin* announced the Crane Lecture Series, saying:

> *Every Country Club District housewife should make her plans so that she will be free to devote her afternoons and evenings the week of April 18 to the Ross Crane Better Homes Institute. No one can afford to miss a single lecture. Mr. Crane…is known throughout the country as the man who "paints pictures with furniture."* [During] *two sessions a day, he holds a practical demonstration on home furnishings, with occasional excursions into such kindred subjects as house planning, landscaping the home grounds and improving the city as a whole.*

Children are always a reader-generating topic for any publication, and the *Bulletin* was no different. Thanks to the schools, the parks and the organizations the district and the homes associations had created, there was plenty to discuss. There was kite flying and model boat sailing and recitals of every sort. A regular feature in the *Bulletin*, and a favorite among the families of the district, was the Country Club District's Annual Field Day.

The *Bulletin* always featured an extensive front-page article on the event with a photo array featuring the many competitions. According to the coverage on the inaugural event in 1921, the events included "dashes for the older boys and girls, obstacle races, relay stick races, a special group stunt for each school, chariot races, rope skipping, three-legged races, sack races, tugs-of-war and a kiddie car race for the littlest ones." The article claimed there were four hundred children officially entered and two thousand family members in attendance. All winners were proudly announced in the article, along with both their families and their school affiliations.

J.C. Nichols appears to have been personally involved in some of these events. An article in the June 1919 edition reported that the planned "Pageant of Magic, Mystery and Mirth" to be presented by Eugene Laurant & Company had to be moved from the lawn of one of the country clubs to the auditorium at St. Teresa's Academy due to rain. "It was all Mr. Nichols could do to prevent a stampede of kiddies scrambling over one another" when the magician asked for a volunteer, and then later, "Mr. Nichols' announcement that some entertainment, possibly a barbecue or wienie roast, would be given for all the children of the District early this fall, was received with cheers."

The *Country Club District Bulletin* also proved to be a less than subtle way for J.C. Nichols to promote civic causes he felt were important to the district. There is no evidence in the available copies of the *Bulletin* to suggest Nichols ever used the newsletter to endorse an individual candidate. But each edition typically included a short piece devoted to a current matter of interest to the community. The article "Blue Valley Development Important" encouraged residents to support improvements in another part of town, displaying Nichols's broader civic sensibilities. "Do Not Fail to Vote for Water Bonds" was another measure Nichols supported because of its positive impact on development. Nichols was passionate about Kansas City enjoying all the cultural advantages of every major city, so some articles tried to foster support for those measures, like "Kansas City Needs a Symphony Orchestra" or repeated calls to establish a local university.

In October 1930, after more than eleven years and one hundred editions, the Nichols Company ceased publication of the *Country Club District Bulletin*. The economic constraints on the company created by the Great Depression a year earlier necessitated cutbacks in many areas of the Nichols Company's operations. The loss of the *Country Club District Bulletin* was likely the one most apparent and most missed by the average district resident. The

newsletter had served well the role of a community paper. But to survive the bad economy, the Nichols Company was now turning most of its attention to a part of its business that would soon prove essential to its survival: its new shopping districts.

THE NICHOLS COMPANY'S "OUTLYING SHOPPING CENTERS"

The commercial shops in the Country Club District were always as much a part of the Nichols Company's plan as the housing. Starting in 1905 in Bismark Place, the modest Colonial Shops development at Fifty-first and Oak Streets was the company's first venture into commercial space. Nichols's ambitions here were simple. The shops gave his new homeowners needed access to basic goods. The first business in the Colonial Shops was a grocer, the most essential of services. Nichols also wanted to promote the use of the new streetcar line that ran next to the Colonial Shops, connecting the Country Club District to downtown through Westport. A few years later, the company built another small cluster of shops at Fifty-ninth and Main Streets. The Nichols Company used these two small developments to learn about building for retail shops and professional tenants. By the mid-1910s, Nichols had learned enough that he was already planning what are arguably the company's most lasting developments: the Brookside and the Country Club Plaza shopping centers.

Nichols knew that unless his Country Club District residents had ready access to the full complement of conveniences to which they were accustomed, they might be inclined to relocate out of the district to newer, more accommodating subdivisions. By now, Nichols had lots of local competition. Other real estate companies were thriving in his wake, replicating his methods and parroting his claims. Working generally in the areas east and south of Nichols Company territory, the competitors were either not as ambitious or not as well financed, for their scale of development came nowhere close to that of the Nichols Company. Nichols did not mind competition so long as these rivals were building housing that didn't detract from the standards established in the Country Club District. Besides, his competitors were building housing that would only increase the demand for the commercial centers he was planning.

And as he had done with residential development, J.C. Nichols and his lead staff set upon the task of learning everything there was to know

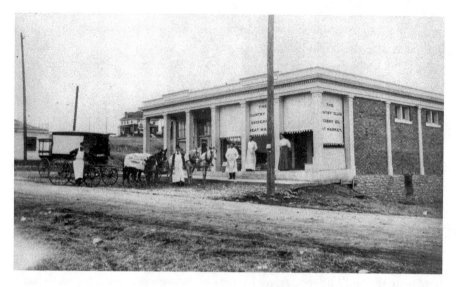

Nichols's first commercial development, the Colonial Shops at Fifty-first and Oak, 1905. The tenant is the Country Club Grocery Co. Nichols's first Bismark Place housing is seen on the hill in the background. *J.C. Nichols Company Scrapbooks (K0054 v4p112); State Historical Society of Missouri Research Center, Kansas City, MO.*

about this new commercial model. From that research, a host of principles emerged that guided the Nichols Company as it began its large-scale retail development. *The Community Builders Handbook*, Nichols's 1947 publication for the Urban Land Institute, outlines in astounding detail every conceivable parameter of how an outlying shopping center should be planned, built, managed, promoted and rented, down to a menu of shops that are "necessary" for success.

In 1912, Nichols started working on plans for that first center that became the Brookside Shops. Brookside was to be a true shopping district, not just a cluster of shops running along one side of a single block. Nichols chose the location at the intersection of Sixty-third Street and Brookside Boulevard for its proximity to the streetcar line and what promised to be major arteries in the city's road system. The Nichols Company started by giving property to the city on Sixty-third Street for a new combined fire and police station to serve the Country Club District. As of 1911, the city limits extended all the way to Seventy-seventh Street. The Nichols Company no longer had to make special arrangements with the city and independent contractors for services like fire protection and garbage collection. The city constructed a state-of-the-art station on that Sixty-third Street lot, built as a beautifully designed Gothic revival

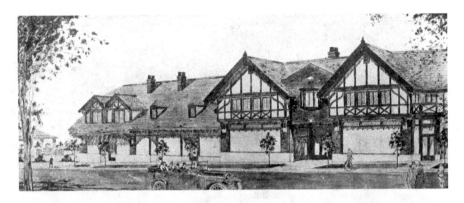

When it opened in 1919, the Brookside Shops were the first of what Nichols's called his "outlying shopping centers," predating the Country Club Plaza by four years. This illustration previewed the shops in the September 1919 issue of the *Country Club District Bulletin*. *Missouri Valley Special Collections, Kansas City Public Library, Kansas City, MO.*

structure. The Nichols Company shops would have a similar look. Nichols started working with noted city planner John Nolen in 1915 on an English Tudor–type façade for his Brookside Shops.

Above an illustration of a large building resembling a row of old shops plucked from England's Elizabethan era, the September 1919 issue of *The Country Club Bulletin* announced the pending opening of the Nichols Company's "first group of neighborhood shops," located at the corner of Sixty-third Street and Brookside Boulevard. In describing the building, the article promised that it would be surrounded by plantings and other details that would afford it "an atmosphere harmonious with the residential surroundings." The reader was also told that the aptly named Brookside Building, with its construction price of $75,000, would be the first of eight to be built in the same style branching out from that central intersection and that two other shopping centers were in the works for other sites within the Country Club District.

The Brookside Shops were reflective of a larger trend toward greater consumerism that the age of the automobile and America's growing middle class had made possible. Since many of the district's new residents were also first-time homeowners, they needed basic furnishings, and often they had the budget for luxuries. All the intelligence J.C. Nichols had gathered before 1919 showed that he should locate these centers about every five miles apart to meet the tolerances of his residents for traveling to shop. This phenomenon of clusters of commercial areas far away from a city's center, larger in size than a corner mercantile but smaller than a downtown one,

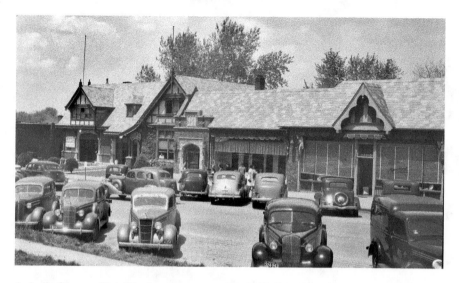

A classic Country Club District street scene, circa 1934. From the window of the police station, a man watches patrons outside the Brookside Cake Shop on Sixty-third Street. *Wilborn & Associates.*

was growing all over the country, and in the real estate industry, it came to be known as "outlying shopping centers."

The Nichols Company continued work on the Brookside Shops for the next seventeen years, even as other projects came on line. Nichols followed Brookside with the Crestwood Shops at Fifty-fifth and Oak Streets. This site was, once again, immediately next to the streetcar line. Crestwood was smaller than Brookside, just a block long on one side of the street in the manner of the Colonial Shops. Built in 1922, the Crestwood Shops featured a Colonial revival design, and although they were primarily meant to serve the immediate area, they became a popular stop for streetcar passengers. The Tudor style of Brookside and the Colonial revival styles of Crestwood and the Colonial Shops were part of the Nichols Company's strategy to give commercial areas an appearance more compatible with residential areas than the typical unadorned brick or wood-frame commercial building of the period.

For the northern end of the district, Nichols had something else in mind, something that would appeal to shoppers both within and beyond the Country Club District. Here was a gateway to the district—the place where the district met the old town of Westport and where Kansas Citians traveling south from other parts of the city first encountered the district. As Nichols envisioned it, that gateway, the Country Club Plaza, would be a citywide shopping center. Of course, it must still provide those most basic of services—grocery stores,

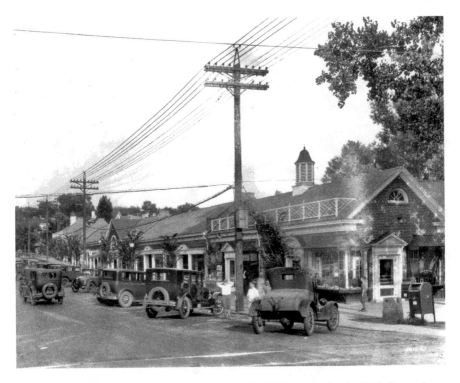

The Crestwood Shops also predated the Country Club Plaza, opening in 1922. Located at Fifty-fifth and Oak Streets, the shops served the nearby Crestwood neighborhood. *Wilborn & Associates.*

clothing stores, pharmacies, goods for the home—but it would also be a shopping destination. The Country Club Plaza was going be larger and more architecturally elaborate, with a wider array of shops than anywhere else, not just in the Country Club District but also in Kansas City and, if Nichols had his way, perhaps throughout the country. Nichols began planning the Country Club Plaza when the area was first platted in 1911, though it wouldn't be until 1923 that actual construction began.

The Country Club Plaza Shopping Center remains the Nichols Company's most dramatic use of an architectural motif. It was also among the company's most complicated and challenging projects. Nichols started acquiring property around the site just north of Brush Creek and west of Mill Creek Parkway and Main Street in 1912, eleven years prior to its official opening. Even then, others were already invested there. A year before Nichols, developer George F. Law started purchasing property near Brush Creek. Law's scheme was simple: he subdivided the area and gave

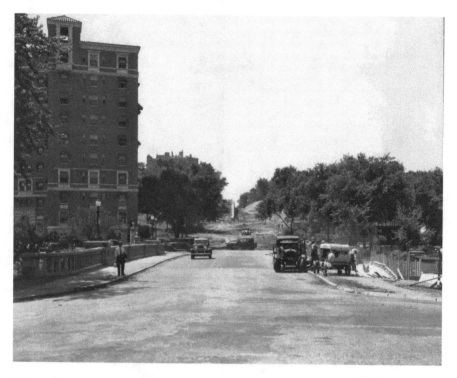

Wornall Road looking south from the Country Club Plaza, circa 1930. Although the Nichols Company started the Plaza in 1923, it took time for city infrastructure to catch up to Nichols's pace of development. *Wilborn & Associates.*

it the name Country Club Plaza, generously borrowing the Country Club appellation from the Nichols Company. Then, making no improvements to lots filled with wild brush and rocks, Law advertised them to out-of-town buyers, who eagerly snatched them up on the basis of promised returns. When Nichols came calling, Law was happy to sell him the remaining lots. For those lots that Law had already sold, the Nichols Company had to track down more than one hundred different property owners and then negotiate terms with each of them for the resale of their lots, at an estimated cost of more than $1 million to the company.

There were other obstacles in the development of the Plaza. For several years prior, the Lyle Brickyard and Rock Quarry had operated on the southern slopes of Brush Creek, just north of Bismark Place. The brickyard had been one of the nuisance businesses J.C. had encountered there that convinced him of the necessity of deed restrictions. Nichols managed to close down the operation in 1920, which left its owners feeling less than conciliatory when Nichols finally

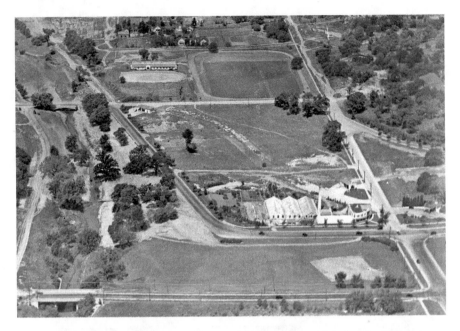

This 1923 aerial shows what existed at the Country Club Plaza site before the Nichols Company started building. Chandler's Nursery & Floral is seen in the lower section; the oval in the upper left is the Parkview Riding Academy. *J.C. Nichols Company Scrapbooks (K0054 v6p106); State Historical Society of Missouri Research Center, Kansas City, MO.*

tried to acquire the property just a few years later. The final agreement was two years in the making and also included separate negotiations for a hog farm and a dumpsite that overlooked the Plaza site.

Though built on the same principles, the Country Club Plaza would be nothing like any of the Nichols Company's shops built before or after, nor would it follow the company's usual development strategy. In 1917, Nichols convinced Chandler Floral, a popular florist and nursery, to relocate from its original location in Hyde Park. The Nichols Company built Chandler a new nursery building at Forty-seventh and Main Streets. In 1920, the company replaced that building with one built in a Spanish architectural style. Two years later, construction began on the first Nichols Company build-to-lease property on the Country Club Plaza, on the northeast corner of Forty-seventh and Wyandotte Streets. The construction was announced in the *Country Club District Bulletin* in November 1922:

> *A building whose design betrays the influence of ancient Spain, with roof*
> *of tile in tones of apricot and Indian red; arches with designs of mosaic*

tile set in buff-colored stucco; a broad horizontal band at the second floor level, ornamented by glazed terra cotta in tones of blue, green and yellow; an overhanging roof, gay with brilliant colors—these are the highlights in the first structure that will be a part of the Country Club Plaza.

The Country Club Plaza was intended to serve the adjacent residential areas and the Country Club District in general. As the article in the *Bulletin* explained, the shops of the Country Club Plaza were designed to "serve the southwestern section of the city in general." The Plaza was the Nichols center that would have it all—shops, restaurants, theaters, clothing stores, home furnishings, dime stores—and all of a quality designed to attract Kansas Citians for miles around. In time, the Country Club Plaza would gain a national reputation as a leading shopping center for high-end merchandise. In fact, in a speech to one of the regular gatherings of plaza employees, merchants and apartment managers, J.C. Nichols gave full voice to the ambitions he had for the Country Club Plaza. "The Plaza project

The first three buildings the Nichols Company constructed in the Country Club Plaza, as seen in 1937, near Forty-seventh Street and Jefferson. The beautiful Plaza Theatre building is on the left. *Missouri Valley Special Collections, Kansas City Public Library, Kansas City, MO.*

was conceived in absolute faith in Kansas City destined to be the third greatest city in America," he declared. If his aspirations for Kansas City fell somewhat short, those for the Plaza did not when he added, "We regard [the Plaza] as one great department store, with every component helping every other part."

The Nichols Company built other commercial centers over the years. In 1927, they opened shops at the intersection of Sixty-third Street and Troost Avenue. In later years, the site was known as "The Landing." This center was the only one built by the Nichols Company during J.C.'s lifetime that was not directly adjacent to other Nichols Company developments. The city of Fairway, Kansas, incorporated in 1949, also had a Nichols Company shopping district. The Fairway Shops at Shawnee Mission Parkway and Belinder Road occupy about two square blocks built in a Colonial style similar to Crestwood. The last large-scale shopping district planned and initiated during J.C. Nichols's lifetime was the Prairie Village Shops, begun in 1947. At the confluence of the cities of Mission Hills and Prairie Village, the Prairie Village Shops became a major retail and neighborhood hub for the westernmost portion of the Nichols Company development, just as Brookside served for the eastern portion.

The Nichols Company's network of shopping centers created a connective tissue for the Country Club District. Each shopping area had its own merchants' association, organized by the Nichols Company but eventually transitioning into a self-governing body, much like what had been done with the homes associations. These merchants' associations worked independently on their individual events. They also worked together as the collective Nichols Company centers, gathering regularly to discuss problems of common interest and coordinate promotions. The *Country Club District Bulletin* featured a regular listing of current businesses in each center, as well as an ongoing update of new and expanding businesses. The Nichols Company and its merchant tenants printed business directories for distribution throughout the district, made available in all the shops. During the 1930s, in the midst of the Depression, the shopping centers' promotions and community events served in lieu of those that the Nichols Company used to sponsor.

During the Depression, the shopping centers provided a great deal of stability for the company and the district because of the innovative lease structure Nichols devised. In 1919, largely in anticipation of this expansion in commercial development, the Nichols Company transitioned from charging retail rents using a flat rate (generally based on square footage) to

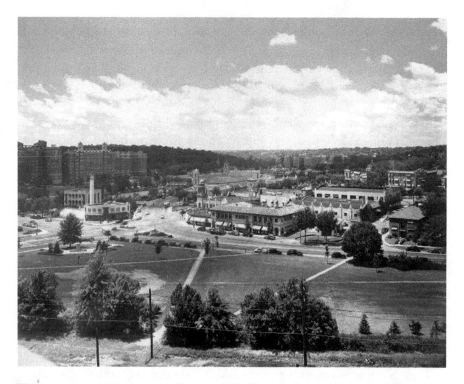

The intersection of Forty-seventh Street and Mill Creek Parkway looked very different in the late 1940s than it does today. Alameda Road entered from an angle, the original Venetian Fountain sat in the middle of the street and the smokestack (left) that heated Chandler Floral's greenhouses was a Plaza landmark. *Missouri Valley Special Collections, Kansas City Public Library, Kansas City, MO.*

a "percentage lease" rate. In theory, the percentage lease was a simple concept. A retail tenant paid a predetermined percentage of its monthly sales as rent. In practice, the calculus involved in establishing that predetermined percentage was not simple. The percentage lease typically began with a base rent, which guaranteed the company's ability to cover basic property maintenance costs. Beyond that, there was much to consider. As Nichols outlined it years later in *The Community Builders Handbook*, "Percentage leases are based upon the ability of the merchant to pay, the kind of business, the volume of business per square foot, the profit made on the merchandise, the importance of the location, absence of too much competition, and similar factors."

Nichols shared his new approach with his colleagues among the deans of American real estate development, but they were not persuaded that the percentage lease model was for them, even though he told them that the new arrangement had doubled his previous commercial income. With

the percentage lease structure, the Nichols Company was effectively in a partnership with its retail tenants. In a system where the rent was tied to the level of business the company experienced, tenants were more often able to meet their basic rent requirements. That stability in its tenant base gave the Nichols Company a revenue stream it desperately needed when the bottom fell out of home construction and sales in 1930. The percentage lease also gave Nichols a role in the operations of his tenants' businesses, something that appealed to him. In fact, the pertinent section on leases in *The Community Builders Handbook* captures a classic J.C. Nichols philosophy— that of forging a partnership between the Nichols Company and all those it was trying to serve:

> *Percentage leases are believed to be the fairest rental method for both landlord and tenant. The percentage lease arrangement might be looked upon as a form of partnership between the owner of the property on the one hand, and the occupant on the other. The owner furnishes the location and usually the store building, parking space, access, etc.; the tenant supplies the commodities to be marketed. Both are essential to the operation of the business. The skill with which each is done affects its success.*

Nichols's detailed interest in his commercial properties extended beyond the leases into the very management of the stores. Here his motivation was to create a consistency of experience for those who shopped at his centers. This was particularly true for the Country Club Plaza, where the company's goal was to attract a higher percentage of non-district residents as customers. The Country Club Plaza was the figurative front door to the Country Club District, and J.C. Nichols felt it should reflect the best of everything the district had to offer. In a 1933 speech to the tenants and residents of the Plaza, Nichols took great pains to explain the nuances with which the Plaza was built and how it is operated as a forerunner to outlining, in very clear terms, his expectations of everyone who worked in a Country Club Plaza shop. The forty "tips" Nichols offers to sales clerks working in plaza shops covers everything from keeping one's nails clean to remembering the names of one's customers' children. While it seems like micromanagement, it's important to remember that J.C. Nichols's greatest talent was salesmanship. As with everything else he did, he believed that even the small details were important.

The 1930s was also the era when the Nichols Company started major events to promote its shopping districts. For Easter 1932, the company installed Easter Bunny statues on the sidewalks around its various centers. The rabbit statues,

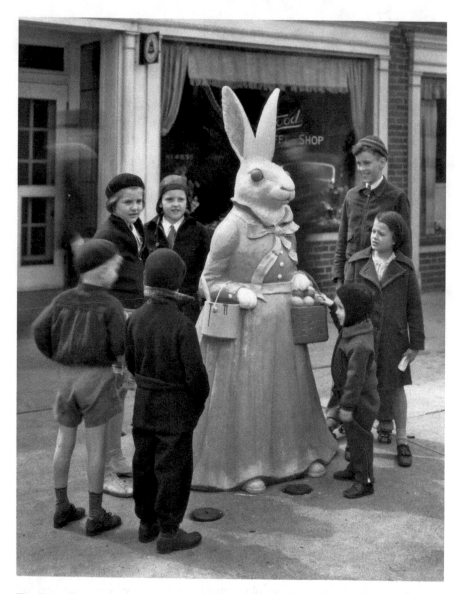

The Easter Bunny statues have been popular decorations for years. Here, children gather around one of the bunnies in 1936, at their original location at the Crestwood Shops. *Wilborn & Associates.*

human-sized, with brightly colored, painted-on clothing and made of an early form of fiberglass, were instantly popular. In just a few years, the bunnies became the exclusive denizens of the Country Club Plaza. An Easter Parade was added in the 1940s. In September 1932, the Plaza Merchants' Association

The first annual Plaza Art Fair, held in 1932. The art fair started small; that first year, the entire event fit into the undeveloped lot at Broadway/Wornall Road and Ward Parkway. *Wilborn & Associates.*

put on its first annual Art Fair on a single city block of then-vacant property at the northeast corner of Broadway Avenue and Ward Parkway. There were ninety-five artists in attendance, all of them local.

The highlight of the Country Club District event calendar was the Christmas season. The earliest record of a district-wide Christmas event was a mule-drawn wagon filled with Nichols Company employees who rode around the district singing carols. That tradition began in 1919 and continued for many years. In 1921, a district Christmas tree was added, as was a Christmas pageant. The district's own Women's Community Council provided the tree, placed at the corner of Westover Road and Brookside Boulevard. As related in the December 1921 issue of the *Country Club District Bulletin*, the pageant followed the story of the "Knight of 1921," who rescues the "Christmas Spirit." The villain of the set piece was "Selfishness." The actors were residents of the district; the twenty-five elves that made up "the Heart of the World" were students from two district elementary schools, Bryant and Border Star.

In 1925, the district's modern Christmas tradition began when the Plaza Merchants' Association adopted the policy of decorating the sidewalk in front of each store with a small tree. The Nichols Company's contribution was a string of lights over its original building at Forty-seventh Street and Mill Creek Parkway. Each year thereafter, the lighting program was expanded, until eventually every Country Club Plaza building was trimmed in lights of all colors. The Plaza Lighting Ceremony, when the lights are turned on for the first time each Thanksgiving night, began in 1930 and has not missed a Christmas season since.

As a shopping center, the Country Club Plaza quickly became the metropolitan-wide center Nichols had planned and an enduring icon of the Country Club District itself. The Plaza was mostly built out by the time of Nichols's death in 1950, although additional development has occurred around its perimeter. The Nichols Company continued to revamp the Plaza for many years, including reconstructing whole blocks and realigning streets. Through all those changes, however, the company retained the original architectural character. Elsewhere around the district, each center—Brookside, Crestwood, Prairie Village and Fairway during the J.C. Nichols era—gained its own following and became known for its unique events and merchants. The shopping centers' role in providing

Begun by the Plaza Merchants Association in 1925, this view of the Plaza Christmas Lights in 1937 glows in the winter moonlight. Chandler's Nursery is seen on the left, decorated with the large star. The small star in the middle of the photo hangs over the Plaza Theatre Building. *Missouri Valley Special Collections, Kansas City Public Library, Kansas City, MO.*

a means of connecting the community worked just as J.C. had planned, and the centers' ability to keep the J.C. Nichols Company afloat during hard times proved their worth. In fact, the role of the shopping center was already making fundamental changes to the company's business model, but the full effect of that shift was still years away.

SCHOOLS AND CHURCHES, THE CORNERSTONES OF COMMUNITY

Schools and worship houses have always stood at the center of communities, often literally but certainly figuratively. Whatever prompts the spirit to put down place, faith and education are likely among the first things to be established. On the land south of Brush Creek, both were already present well before J.C. Nichols decided to make the place his Country Club District, but in keeping with his character, Nichols wasn't content to let such important matters happen by chance. For much of the first thirty years of the district, Nichols made it a priority to forge relationships that would bring more schools to the district and to encourage more congregations to build there.

Nichols took a three-pronged approach to secure the right mix of schools—public, private and parochial. His interest in good public schools for the Country Club District put him in the role of candidate for public office. Nichols was elected to the Kansas City, Missouri Board of Education in 1918 and served for eight years. While he was actively involved in civic leadership his entire career, his tenure on the school board was the only time J.C. Nichols sought any kind of political office. This was a partisan election at that time, and Nichols ran as a Democrat. He took on the responsibility because it tied so directly to his belief that cities in general, and Kansas City specifically, needed to embrace professional city planning. City planning encompasses everything about which Nichols cared deeply for the Country Club District—zoning, building standards, streets, utilities, parks and, most definitely, schools. He lobbied city officials on the need for planning in general and on specific planning issues individually. But for the schools, he chose to serve.

The earliest school in the area was Border Star, established in 1863. In 1873, a wood-frame school building was constructed near what would become Sixty-third Street and Wornall Road. The original school sat at the north end of the lot. When the area was incorporated as part of Kansas

City in 1911, Border Star was absorbed into the city's school district. The old building stood vacant during World War I but reopened in 1919 just as the adjacent Brookside Shops were first built. In 1921, when the Nichols Company was promoting the new subdivisions of Hampstead Gardens, Stratford Gardens and Greenway Fields just west of the school site, the map of the area in the brochure showed plans for a new building on the same lot but south of the original. That new Border Star school was built in 1923, during Nichols's tenure on the school board.

Just six blocks north of Border Star, at Fifty-seventh Street and Wornall Road, the school district built the William Cullen Bryant School in 1915, before Nichols joined the school board. But the building was given its first major renovation in 1920, while Nichols was on the board. Nichols's influence notwithstanding, the rate of population growth throughout the city necessitated a good many school renovations during this period; Bryant would likely have been renovated without Nichols's involvement. The final Nichols-era elementary school was located at Sixty-ninth and Oak Streets. It

Southwest High School's Spring Celebration, 1930. Southwest High School was the alma mater for many of the district's children for generations, catering to families on both sides of the state line. *Wilborn & Associates.*

opened in 1926, but it was the end of the first school year before it was given its official name—the J.C. Nichols School. Like Bryant, the Nichols School underwent several renovations—but after Nichols left the school board.

Southwest High School became a landmark building and a community touchstone for the Country Club District. This school, built in 1927 on donated Nichols Company property at Sixty-fifth Street and Wornall Road, was the first public high school to serve the district, but its reach extended well beyond that border. Southwest High School served the nearby Waldo neighborhood, just south of the district, and it also included children from the Kansas side of the district. During the 1920s and '30s, the Kansas City school district extended enrollment to children in families in Mission Hills, Indian Hills and other Kansas-side subdivisions. The Kansas school system was still developing, and many of these communities were still unincorporated. Southwest High School was an attractive choice for many families. The demand on Southwest High kept the school facilities in a near perpetual cycle of renovation all the way through the 1920s and '30s.

Early on, Nichols focused his energy for education on securing good private schools for the district. It was not that Nichols had prioritized private schools over public. It was simply that, in 1910, Nichols was presented with an opportunity he couldn't afford to ignore. Nichols's partner in the Sunset Hill development, Hugh Ward, died suddenly in 1909 at the age of forty-six. Ward had inherited his considerable acreage from his father, Seth Ward. But he had been a lawyer and was a man of means in his own right. His estate passed to his widow, thirty-four-year-old Vassie James Ward. The Sunset Hill project was only recently begun.

Vassie Ward had a keen interest in education. As a young mother, she did not agree with the convention of the day that sent children from wealthy families to eastern boarding schools, the only place where a "decent" education could be found, it was believed. She saw no reason why such an education shouldn't be available in any town, including Kansas City. Mrs. Ward shared some of J.C. Nichols's Progressive Era leanings, and in the area of education, those leanings led her to the writings of philosopher and noted education reformer John Dewey. Dewey's view of education moved away from the traditional rote instructional approach and toward experiential learning. Those who shared that philosophy developed the "country day school" model of education. Instead of living far from home on residential campuses, "country day" students enjoyed the same immersive educations that eastern preparatory schools provided but while living at home. The key was to build the country day school in a country-like setting. While country

day schools had existed in the older East Coast cities for more than thirty years, the approach was new to Kansas City. Until the development of the Country Club District, there was no area of town with the right mix of population looking for this type of education in a place that still retained the qualities of a rural setting.

The Nichols Company provided the property for the two schools that Vassie Ward helped create. The first to form was Country Day School in 1910, built with backing from local businessmen, including J.C. Nichols. Despite the name and the model of non-residence, the school did accept a few boarders until the 1950s. Its first, albeit brief, location was the Wornall Homestead during a time when the property belonged to the Nichols Company. As soon as the school's first facility was built, Country Day moved to its permanent campus at the northeast corner of Ward Parkway and State Line Road. In 1913, the second school, Sunset Hill, was formed to educate girls. Sunset Hill's campus overlooked Brush Creek from the south, just north of the grounds of the Kansas City Country Club and directly adjacent to the Sunset Hill subdivision. In 1925, Pembroke Hill School for boys was formed by a break-out group from Country Day, but the stresses of the Great Depression caused the two schools to become one again in 1933. Pembroke–Country Day carried that combined name for more than fifty years. For some time, the district was serviced by another private school, the Barstow School for girls. Originally located downtown, Barstow relocated to the edge of the district at Fiftieth and Cherry Streets in 1925, remaining there until 1962, when it moved to a new campus in southern Kansas City after a decision to admit boys.

J.C. Nichols started courting parochial schools for the Country Club District early on in his career. Once again, an opportunity arrived, this time in the form of a land deal that brought St. Teresa's Academy to the district. In 1908, just as the Country Club District was taking shape, the Simpson Yeomans property near modern-day Fifty-fifth and Main Streets represented a significant tract in the middle of land that the Nichols Company had already acquired for development. Mrs. Kate Simpson Yeomans, who had inherited the property from her father, was willing to sell but wanted cash for her property. By this time, the Nichols Company's rapid pace of property acquisition had exhausted both liquidity and credit. But J.C. Nichols had heard that the venerable St. Teresa's Academy, located on Quality Hill, wanted to expand and was looking for a new site. St. Teresa's was the city's oldest schools for girls and a Catholic school well attended by many Protestants. Better still, it had cash to pay for property. The school's

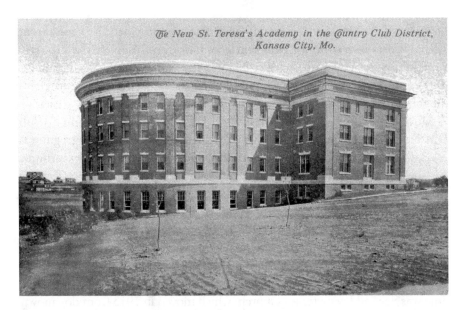

A postcard view of St. Theresa's Academy, dating from 1913, shortly after it was built in the district, with the help of J.C. Nichols. *Author's collection.*

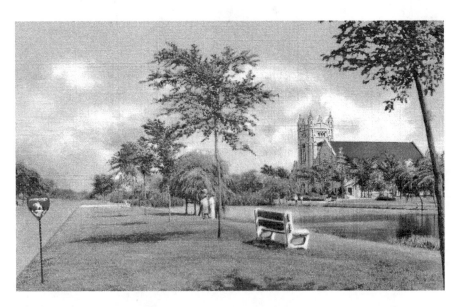

The Community Christian Church, shown on the right in this 1945 postcard, is barely visible above the tree line on Ward Parkway. The reflecting pool on Ward Parkway was a popular spot for model boating and ice-skating. *Author's collection.*

payment of $40,000 for the twenty-acre property provided the capital that Nichols needed to close the Simpson Yeomans transaction. If the property wouldn't be available for housing, Nichols still came out ahead; having St. Teresa's provided an important community asset and the chance to claim the school's prestige as a feather in the cap of the Country Club District.

More Catholic and church-based schools came to the Country Club District over the years, but primarily as a result of existing congregations relocating or expanding into the district or the establishment of brand-new parishes and churches. Perhaps because of the early role of St. Teresa's Academy or the fact that Visitation Parish began just south of Bismark Place at Fifty-first and Main Streets about 1909, the Catholic community was always a large part of Country Club District life. Among his colleagues in the real estate industry, the Nichols Company was unusual among like developers in that it never restricted sales to Catholics.

The first church to relocate to the Country Club District during J.C. Nichols's time was Second Presbyterian Church, which moved in 1915 from downtown

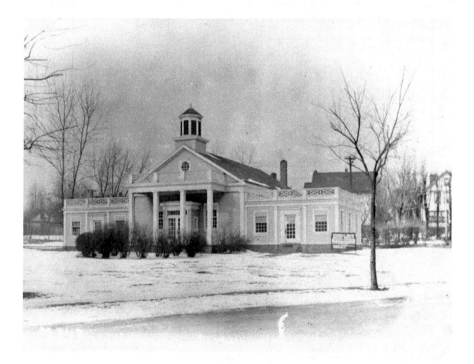

Wornall Road Baptist Church was one of many churches that opened in the district to serve the area's new residents. The church, which opened in 1921, is seen here in 1930. *Missouri Valley Special Collections, Kansas City Public Library, Kansas City, MO.*

to Fifty-fifth and Oak Streets. The move followed a census of its membership of five hundred that its members were moving south. Seven years later, and after the relocation, Second Presbyterian's congregation had increased 60 percent over its earlier membership. Other congregations—Protestant and Catholic—soon followed, including St. Andrew's Episcopal Church (1916) and Wornall Road Baptist Church (1920), both at the intersection of Wornall Road and Meyer Boulevard. Other churches that relocated at the urging of Nichols or other prominent members of the district included Nichols's own church, Country Club Christian Church (1920), at Sixty-first Street and Ward Parkway; Country Club Congregational Church (1921), at Sixty-fifth Street and Brookside Road; and the Sixth Church of Christ Scientist (1925), at Sixty-sixth Terrace and Wornall Road. Country Club Methodist Church (1913), at Fifty-seventh Street and Wornall Road, was formed as a new church in the district, reportedly because of a lack of a Methodist church between Westport and the community of Waldo.

As it so often did, the Nichols Company expressed its belief in the importance of developing these institutions in a piece in the *Bulletin*. Under the title "Church Building Steadily Advancing in Country Club District," the August 1922 cover story described the philosophy:

> *The home, the school, and the church together, are the great social institutions of American life…The public and private schools in which the boys and girls of the Country Club District are being educated are second to none. The church development of the District has been somewhat retarded, because many who came to the District maintained, for a time, their connections with the organizations in their old neighborhoods. It is but natural, however, that a community in which home life is the dominant note, would give expression to its higher purposes through its activities relating to the church, and having come to desire association with neighbors and friends in their own immediate vicinity, church congregation building in the Country Club District is now in process at a marvelous rate.*

THE DISTRICT'S COUNTRY CLUBS

In his writings and speeches on the general principles of creating high-quality residential districts, J.C. Nichols put the most emphasis on community features that truly benefited the larger community. Chief among those were the

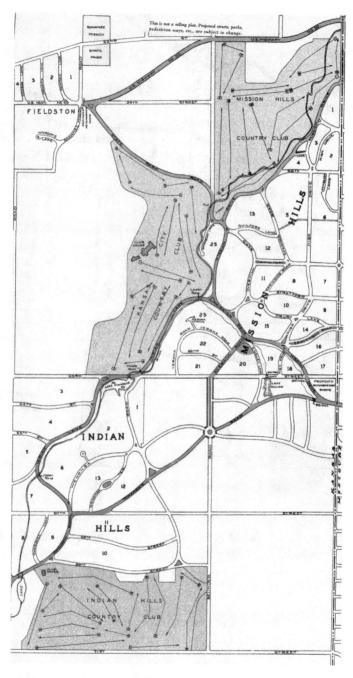

This 1930 Nichols Company map clearly displays the three country clubs most associated with the development of the original Country Club District. *Missouri Valley Special Collections, Kansas City Public Library, Kansas City, MO.*

schools and churches. But in the real-life setting of the Country Club District of Kansas City that the Nichols Company built, the country club or golf club played a particular role as an attraction to a few key investors. It was no accident that Nichols co-opted the "Country Club" name for the district. The term elegantly and efficiently located the district in the city's geography and imprinted the district with a mark of prestige.

Country clubs started in earnest in America around the late 1880s, predominantly in eastern cities. Industrialization had created wealth, and many people could now afford to take day excursions to escape the filth, heat, stench and other consequences of dense city life. The country club concept had its roots in men's clubs that had been part of city life for more than a century, so the nineteenth-century country club was originally more than a golf course. It was common for country clubs to offer some combination of hiking trails, polo grounds, tennis courts, billiard rooms, boating ponds, bowling alleys and occasionally casinos as entertainment for its male members.

In fact, a country club without golf was not a rarity. Organizing a country club as a golf club was a large-scale project. A country club could range in the size of the land, depending on its uses. But a golf club required significant acreage that had to be maintained, albeit at a far rougher standard than the modern golf course. Locating a golf country club was no small matter, either. In the late 1800s, Kansas City's first golf club started with a group of Kansas City's up-and-coming civic leaders playing in a small area in the midst of the affluent neighborhood of Hyde Park. In fact, many had moved to the Hyde Park area, attracted by the notion of living in the suburbs. But then the neighborhood grew up around the small course, choking off any chances for growth. Hugh Ward was among the club's early members. Hugh Ward was the one to lease some six hundred acres of his cow pasture to relocate the club south of Brush Creek. In 1896, the group formally incorporated as the Kansas City Country Club and moved to the Ward property.

Little more than a decade later, the club was adequately established to be a formidable attraction to Nichols in his search for development property. But when the work in Bismark Place began, Nichols used the proximity only as a marketing draw for his new housing. In 1909, when Nichols entered into the venture with Ward for construction of Sunset Hill, Nichols saw the country club acreage as a centerpiece—a space that provided the bucolic effects of a park that was maintained by others who had the means to maintain it well. Such a combination is a developer's dream. True, the country club acreage might have had value as housing lots, but Nichols rightly figured

that the country club contributed more value for its appeal to Sunset Hill's future homeowners. Not that Nichols had any choice in the matter; the property was ultimately all in the hands of Hugh Ward and then, shortly, his widow. The Wards were not interested in giving up the golf course for more housing—at least not yet.

Among those early and elite new residents of the Country Club District, most particularly in Sunset Hill, the demand for membership in the Kansas City Country Club soon outpaced the club's membership limitation of one hundred. By 1914, Nichols was at work organizing all the elements for a second country club to serve the district. Like the subdivision (subsequently turned city) that shares its name, the Mission Hills Country Club was built on property purchased by Nichols from the family of the Reverend Thomas Johnson, who had founded the nearby Shawnee Indian Mission and gave Johnson County, Kansas, its name. Nichols served as one of the founding directors of the Mission Hills Country Club, motivated in part to ensure that membership was accessible to his Country Club District residents. He also provided most, but not all, of the property for the club—the Kansas-side property, that is. From the beginning, the Mission Hills Country Club straddled the state line as it ran along the property abutting Brush Creek and the highway (the modern Shawnee Mission Parkway). The club's bi-state location was born of necessity. Since the 1880s, Kansas had prohibited liquor. Fortunately for the planned country club, the Hugh Ward estate owned a parcel adjacent to the planned golf course, immediately to the east on the Missouri side of the state line. That parcel provided the property for the original Mission Hills club house. A small footbridge connected the two properties for the convenience of club members. Even the end of Prohibition in 1933 did not alleviate the need for a bi-state location. Kansas was a holdout for statewide prohibition until 1948. It would not be until the mid-1950s that the Mission Hills Country Club would construct a separate clubhouse on the Kansas side and sell the original clubhouse to the newly formed Carriage Club.

The new Mission Hills Country Club offered only brief relief for the growing demand for golf courses to serve the Country Club District. Soon, Nichols faced a new dilemma. In 1918, the estate of Hugh Ward decided not to renew its lease to the Kansas City Country Club. Nichols had already established a spot for a third golf course on property just south of the Mission Hills Country Club. The Nichols Company had employed experts in golf course layout for the course originally called the Country Club Community Golf Links. This would be the club for any resident of the district, with an

A view of the Mission Hills Country Club golf course, circa 1930, just sixteen years after its founding. The landscaping is less formal than today's course, and one of the footbridges is visible in the background. *Missouri Valley Special Collections, Kansas City, Public Library, Kansas City, MO.*

affordable annual membership fee of thirty dollars. But with the news about the Ward property, Nichols had to relocate the Kansas City Country Club to that site.

Over the next few years, the Community Golf Club—or the "Community Links," as it was often referred to in the *Country Club District Bulletin*—would be moved around to several different sites. The 1919 July edition of the *Bulletin* announced that the Country Club Community Golf Links was in "tip-top condition" at its new location. The course consisted of nine holes on property bounded by Sixty-first Street on the north, Sixty-fifth Street on the south, Pennsylvania Avenue on the east and Ward Parkway on the west. The Lodge, the course's clubhouse, sat at the northeast corner of the grounds. The property also included a community gardens (at modern-day Sixty-first Street and Belleview Avenue) and a nursery at the southeast corner of the property.

This temporary location illustrates how the Nichols Company used golf course development as an interim strategy in its residential development. A

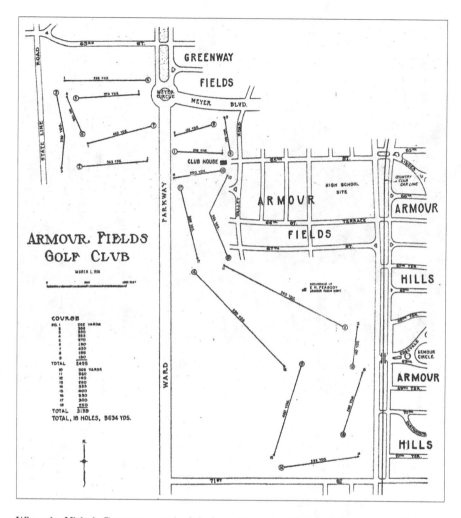

When the Nichols Company acquired the last of the Armour Farm property near Sixty-seventh and Wornall Road in 1923, homebuilding was already slowing down. The April 1924 issue of the *Country Club District Bulletin* reveals the company had already transformed the fallow land into a temporary golf course. *Missouri Valley Special Collections, Kansas City Public Library, Kansas City, MO.*

golf course was an effective way to put undeveloped property to productive use while waiting for the right time to build more housing. Golf courses also provided a reasonable setting for some of the functional needs of the Nichols Company. The nursery located in the southwest corner of the Community Links course provided a place for the company to set up greenhouses, store landscaping materials and keep equipment that would otherwise be difficult to locate in residential areas.

The Features of Community

By 1925, the Community Links of those early days had been permanently relocated to a site on the Kansas side, between Sixty-ninth and Seventy-first Streets, Belinder Avenue and Mission Road. At this location, the club became the Indian Hills Country Club, the third of the Country Club District's premiere courses. But during the 1920s, the demand for golf courses seemingly had no limits. A final course was planned and initiated for the Armour Fields area north of Meyer Boulevard and west of Valley Road. In time, it, too, would be sacrificed to make room for additional housing.

In his many speeches on community features and their importance to residential development, J.C. Nichols never placed the country clubs as central to success. In fact, in his June 1924 speech, "Suburban Sub-divisions with Community Features," Nichols presents a long list of "community organizations" that he considers important. Most of them were small and simple—the weenie roast at the picnic ovens, the community field day events, a lecture on bird watching or forming a bicycle club. He sums up the role of the country club in the role of the Country Club District this way:

> *Nothing adds more tone to a neighborhood* [than a golf club]*, nothing adds more protection and beauty to your surroundings. A golf club always is a great buffer to protect you from the encroachment of property of injurious uses around your holdings. Great friendships are formed on these community courses…but I doubt they are as much value in the upbuilding of a sub-division as a simple community organization such as I describe.*

CHAPTER 4
THE COUNTRY CLUB DISTRICT AESTHETIC

Are we building our towns and cities monotonously alike, or are we accentuating their particular characteristic features and preserving their objects of natural beauty, scenic value, and historic interest? Let us as realtors create order and beauty that will grapple the hearts and love of our people and inspire them to build for permanence.
—J.C. Nichols, "Planning for Permanence," National Association of Real Estate Boards, November 1948

J.C. Nichols believed that the Country Club District should be beautiful. Instilling a community with art and nature's beauty was just another item on his list of community features, no more or less important than schools and shopping centers. It was during J.C. Nichols's tenure as board president at the Kansas City Art Institute, from 1920 to 1927, that the Nichols Company did its best work in creating an aesthetic for the district. Nichols may have been influenced by his association with KCAI and no doubt took advantage of the opportunity to learn more about the subject and implement his ideas with the help of those he met. But Nichols had been incorporating a sense of design into the district from the beginning. And while Nichols might have been a master architect of the Nichols Company's sales and marketing successes, for its architecture, landform and other elements of design, he employed a battery of architects, landscape designers, planners and engineers.

Fortunately, these talents were at the ready in Kansas City in the early years of the nineteenth century. American cities had capital to invest in themselves; technology was providing new solutions for infrastructure, created by the

A popular postcard subject, the Meyer Circle fountain at Meyer Boulevard and Ward Parkway remains an icon of the Country Club District. *Author's collection.*

demand for better roads, sewers and utility services. Homebuilding across the country—not just in Kansas City—was also fueling that demand. Due in part to its central location, Kansas City was becoming a major hub of talent in the engineering and architecture fields. The city was attracting many of that generation's finest thinkers, most industrious firms and most talented designers, and the Nichols Company had opportunities in abundance.

From the viewpoint of J.C. Nichols, an aesthetic was just another community feature. But that aesthetic has proved to be one of the district's more enduring qualities, largely because of the many and varied ways it has been used throughout the Country Club District. The elements of the district's aesthetic examined here include its neighborhood layout and street form, its residential and commercial architectural styles, its use of public art, its use of the natural setting and, finally, some technical innovations related to design.

The Neighborhood Landscape

The land from which the Country Club District rose started out as mostly open farmland, though the terrain itself was not flat. Most of the early district subdivisions sat along the crest of a ridge, a sort of plateau between

watersheds. Brush Creek ran north along the district's western edges and then turned east just below bluffs at the north end of the ridge, the bluff that had once been the site of the Battle of Westport and would one day overlook the Country Club Plaza. On the east, the small creek that gave Brookside Boulevard its name ran north and fed into Brush Creek. Within that plateau, there were rises and falls, and there were trees, too—particularly where the waters flowed. To make these acres suitable for housing, sometimes the contour of the land had to be changed or trees had to be removed. But where slopes and trees were advantageous to the site, the Nichols Company, with its growing group of advisory architects and designers, learned about the importance of incorporating them into the setting. "In the beginning, I did not think we could afford to set aside the low and broken lands for parks and boulevards," Nichols wrote in a 1923 article for *Good Housekeeping*. "[N]ow we pay enormous prices for them for that purpose. I used to feel that a road must be the shortest distance between two points; now, the longer I can make it, with curves, the more trees I can preserve by winding the drive, the more rocky ledges I can have along the way, the more I find it appeals."

The curving street, the street trees and even the view of the house ahead were all deliberate elements of the district's street-form style, designed to make the area aesthetically appealing. *Missouri Valley Special Collections, Kansas City Public Library, Kansas City, MO.*

THE COUNTRY CLUB DISTRICT OF KANSAS CITY

If anyone played a more instrumental role in shaping the form of contemporary Kansas City than J.C. Nichols, it would be landscape architect and planner George Kessler. Twenty years senior to Nichols, Kessler was more mentor and muse to Nichols than designer-for-hire, though he played that role in the Sunset Hill subdivision. J.C. Nichols was still an infant when Kessler came to Kansas City to begin his career. His first job was with a railroad, planning small excursion parks along its routes. The timing being right, Kessler quickly picked up other projects, opened his own office and developed a solid reputation. The project that would define the career of George Kessler was the work he began in 1892 as landscape architect for the newly formed Park Board of Kansas City.

The country's interest in city parks grew from the progressive City Beautiful Movement, that period's response to the clamor for design on a citywide scale. The City Beautiful Movement has been expressed in public projects from New York's Central Park to the World's Columbian Exposition in Chicago to the redesign of Washington, D.C.'s National Mall. Architecture, monuments and public landscapes were considered necessary elements of a community and a benefit in their ability to prompt deeper thought, to bear a higher standard and even to inspire. William Rockhill Nelson supported the City Beautiful concept, and he used his newspaper, the *Kansas City Star*, to heavily promote the idea of a park system among his readers. Kansas City tried to initiate its own parks system in 1889, but a host of legal challenges kept the matter bound up in court until 1900, though by 1892, the courts had at least settled on Kansas City's right to have a park board. With that, the city was free to create a park plan. It hired Kessler to create the plan with August Meyer, the park board's first president. The plan was for parks but was to take into consideration other aspects of the city's framework for development. The plan was released the following year.

The genius of the 1893 plan was the way in which it used a layout of boulevards and parks to so naturally encourage and define the city's growth. The city was delighted to have a plan that helped it anticipate investments like costly new streets, sewers, gas lines and other amenities. Over the next twenty years, the plan was periodically revised as the city grew. The first major revision was in 1909, when the city extended its limits to just north of Brush Creek—and just short of the development Nichols was starting at the time in Bismark Place. The next major revision was in 1915. By this time, the city went as far south as Seventy-seventh Street and as far east as the newly created and massive Swope Park, the largest park in the city's system. For the first time, the boulevard system that defines the original structure of the

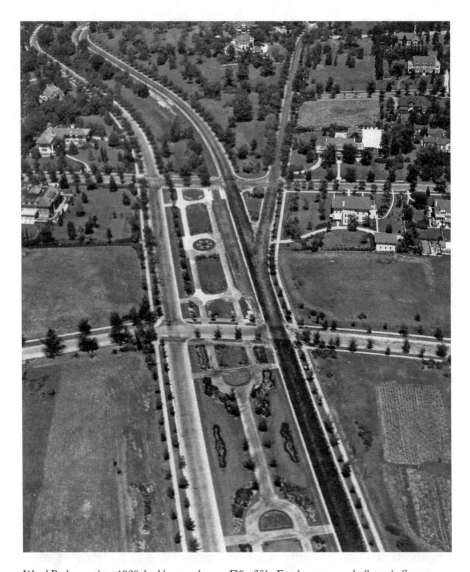

Ward Parkway, circa 1920, looking north near Fifty-fifth. Few houses were built yet in Sunset Hill, but the city was putting a promenade down one of the newest additions to the city's parks and boulevard system. The Corrigan House is seen in the upper left. *Wilborn & Associates.*

Country Club District is visible in Kessler's work, along three sides. Ward Parkway is seen along Brush Creek on the north and then curving southward along the western side of the district. Meyer Boulevard, at that point the short, southern boundary and its connection to Brookside Boulevard, the angular connection along the district's east side, make up the other two.

Kessler's influence on the Country Club District was present before 1915, however. The Nichols Company impulse to control through involvement inspired J.C. Nichols to be a part of the discussions of citywide planning as soon as he became a developer, and it was through that contact that Nichols became personally acquainted with George Kessler. Kessler worked under contract to Nichols and Hugh Ward in their Sunset Hill partnership from 1906 to 1908. Though this is the only district project formally involving Kessler, it is probable that Kessler would have been invited to comment or make suggestions on other subdivisions Nichols was simultaneously developing during the years prior to 1920.

Kessler's reputation eventually took him beyond Kansas City, and his direct influence on the Country Club District lasted for only a few of its early years. The more profound relationship on the aesthetic character of the district came from the Kansas City landscape architecture firm of Hare & Hare, which did most of the Nichols Company's work from 1913 through the remainder of J.C. Nichols's life. Sid Hare and S. Herbert Hare, father and son, respectively, formed the firm in 1919, and through the fertile time of the 1920s, they laid out the entire district's landscape work, from the master plan to the tiny private parks embedded in some neighborhoods. Hare & Hare created individual plans for the subdivisions, determining the contours of the land, the line of the street pattern and the placement of traffic islands, plantings and ornamentation. They determined, within the Nichols Company's parameters, the size of the subdivision's lots and where the house should be located on that lot. They designed walking paths, bridges and streetcar shelters. They also provided landscape designs for individual homeowners, mostly in Mission Hills and Sunset Hill. Outside the district, the firm grew to national prominence, but its most notable local projects include Swope Park and its Kansas City Zoo and the Liberty Memorial.

Hare & Hare's designs for the neighborhood gave it a distinct look. Its neighborhoods are generally organized around a grid pattern like most city blocks, but in each neighborhood, there are usually at least one or two streets that curve, perhaps run at a diagonal or otherwise disrupt the grid form. Those seemingly meandering lines were drawn to take advantage of other features, like a change in topography or the placement of a beautiful tree. The result was subdivisions that were unique but similar. The planned effect, married with the artistry of the district's architecture, is that houses seem individually designed, situated in a naturalistic way, and that whether walking or driving, the traveler through the district should be intrigued by what must be just out of view, down the road and around the bend.

The Country Club District Aesthetic

If district residents failed to notice these careful choices for the sake of beauty, the *Country Club District Bulletin* was there to correct the oversight. In a classic display of its fulsome style and its skill at self-promotion, the September 1919 issue of the *Bulletin* reminded its readers:

> *Do you ever pause to get a real vision of the wonderful beauty of the Country Club District with its charming homes and winding drives, when every street becomes arched over with fine old elm trees framing beautiful views and pleasing vistas in every block, each home approached beneath a bower of magnificent trees? No other section of Kansas City has so many trees so well planted and so well cared for. The mellowing feeling of age and restfulness is already evident in many of the drives that were laid out in the earlier development of this section. Visiting landscape architects frequently comment upon the marvelous effects being so quickly attained.*

DISTRICT ARCHITECTURE, AN ECLECTIC REVIVAL

While the Nichols Company was earning its reputation and its fortune developing the distinctive, individually crafted homes of the Country Club District, other interests around the country were earning their fortunes taking a completely different approach to homebuilding. The "kit home" phenomenon was sweeping the country, led by Sears, Roebuck & Co., a company that knew something about selling to mass markets. The other companies in the catalogue home business were often building material companies that knew something about the potential of a housing market just starting to build up a head of steam.

Sears began its catalogue home business in 1908, the same year J.C. Nichols was launching the Country Club District development. Ironically, the Nichols Company had used Sears-type plan books during the two years just prior to that. But just as Sears was getting into the kit home business, the Nichols Company was getting out. Nichols was in the minority, for across the country interest in the kit home was high. People liked the straightforward approach. A customer selected a home plan from a catalogue of choices, with ranges of homes by size and architectural style. The interior floor plans were illustrated in the catalogue and included in the purchased package. Once ordered, the company shipped the plans, along with almost every building material the homeowner would need. Heavier materials, like cement, brick

THE COUNTRY CLUB DISTRICT OF KANSAS CITY

In addition to his designs for the Plaza, Edward Buehler Delk designed individual homes for the district. This Colonial revival, featured on the cover of the July 15, 1921 *Country Club District Bulletin*, was planned for Mission Hills at High Drive and Drury Lane. *Missouri Valley Special Collections, Kansas City Public Library, Kansas City, MO.*

or stone, were too expensive to ship and were not a part of the package. The homeowner or his contractor purchased those locally. The home was built to the specifications provided, but usually the homeowner made modifications, so each home was unique.

Nichols's concern was that work done this way might not be to the level of quality construction he wanted for the district. The article "The Wise Builder Employs a Good Architect" in the November 1921 issue of *The Country Club Bulletin* explained, "The mistakes of the badly designed house cannot easily be corrected by coats of paint or carved ornaments. Of course everyone knows a brick house from a wooden house. But there is more, much more than the material, which makes the difference between an artistically designed house and a 'thrown together' house."

Nichols's original goal, and that of his lead architect, Edward Tanner, was to build houses that would last two hundred years, although that became a more modest goal of one hundred years following the Depression. But prior

114

to 1930, the Nichols Company was directly responsible for the design and construction of only slightly more than 25 percent of all housing built in the Country Club District. The two-hundred-year goal wouldn't mean much if only one in four houses met that standard. All Nichols could do was use every means available to the Nichols Company to ensure the balance of district housing was to the same standards. Through company promotions and publications, Nichols extolled the virtues of these standards, from both practical and philosophical points of view. Through the powers of the contract—development partnerships, deed restrictions, homes associations and the like—the company created ways to have some reign over non–Nichols Company development. The homes associations were particularly helpful in this regard.

Nichols's goal was for quality, not uniformity of style. The Nichols-era development of the Country Club District coincides with the Eclectic period in American architecture. Eclecticism, which lasted from 1880 to 1940, embraced virtually every style that had come before. The Country Club District's housing is a living catalogue of the styles the period includes—Tudor, Colonial revival, Neoclassic, French, Beaux-Arts, Mission, Prairie and Craftsman among them.

The Nichols Company employed many architects, both in a consulting capacity and as full-time employees. Two names often associated with the Nichols Company are Edward Buehler Delk and Edward Tanner. Both would also become renowned architects with works beyond the Country Club District. Both came to the Nichols Company around 1919, an important year of growth for the company, when many new company practices—like an independent architecture department—were being implemented. Tanner would one day go on to head that department. Delk was the elder of the two, already thirty-four when he came to the Nichols Company. Tanner was only twenty-three, fresh from architectural studies at the University of Kansas. Delk came from Philadelphia, having earned some considerable reputation there, and he would ultimately spend all his professional life between Kansas City and Philadelphia. Tanner was a son of Kansas, born in Cottonwood Falls, raised and educated in Lawrence, whose professional life was spent almost exclusively in Kansas City. Both men designed both commercial properties and individual residences in the Country Club District; some estimates suggest that Tanner alone was responsible for designing some two thousand homes. Given that he was with the company from 1919 to 1964, that figure seems entirely possible and yet still impressive. Tanner's tenure included a long stint as the company's chief designer.

Delk and Tanner's primary legacy is a shared one: the design of the Country Club Plaza. When the two were first introduced to J.C. Nichols and his vision in 1919, their initial assignments were around the design of the "outlying shopping centers" Nichols was planning for the whole district, plans that mapped out their work for the next twenty years. When Nichols had built the Colonial Shops in 1905, the design was straightforward, with only the slightest hint of architectural style. In 1915, noted city planner and landscape architect John Nolen finished work for Nichols on the design scheme that became the Tudor look of the Brookside Shops. Nichols intended to take a similar approach to creating unique styles for his other planned shopping centers. Tanner and Delk, along with Nichols Company vice-president John Taylor and J.C. Nichols himself, spent much time over the next three years traveling across the country looking at shopping center designs and traveling the world in search of just the right architectural style for the centers.

The result was a master plan for the Country Club Plaza, unveiled in 1922, as envisioned by Edward Buehler Delk. Delk is credited with the overall design scheme for the Plaza—a blend of Spanish influences. The earlier buildings resemble Spanish Colonial designs with their red-tiled roofs, sparingly adorned stucco façades and simple arches in windows and doorways. Later buildings more closely resemble the architecture of Seville and southern Spain, where Moorish influences introduce more elaborate tile work, intricate latticework and other façade embellishments. The Giralda Tower on the southwest corner of Forty-seventh Street and Mill Creek Parkway is a half-scale replica of its namesake tower in Seville. Although the tower was not built until the 1960s, J.C. Nichols commissioned plans for the replica tower in the 1930s, proving that the Seville-style architecture was part of the original vision.

The initial Edward Delk plan bears little resemblance to the Plaza as it was initially constructed, which is common with development projects. Though Delk continued his relationship with the Nichols Company and would subsequently design other significant local buildings, most of the design of the first individual buildings is attributed to his colleague Edward Tanner. Whatever the reasons for the shift, Tanner seems to have excelled at the implementation of the vision. The Plaza Theatre Building at Forty-seventh Street and Wyandotte was one of the first three plaza buildings constructed. J.C. Nichols thought Tanner's design for the Plaza Theatre was the Plaza's finest architecture, inside and out.

Both Edward Buehler Delk and Edward Tanner contributed to Kansas City's architectural landscape beyond the Country Club District. Delk

completed the construction of the Community Christian Church at Forty-sixth and Main Streets in 1940. The church had been designed by Frank Lloyd Wright, but Wright had refused to make adjustments in building materials required by city inspectors, so Delk came in with design modifications that finished the project. Delk also designed Swope Park's Starlight Theatre in the 1950s, with its distinctive two-tower profile. Tanner was responsible for the design of Linda Hall Library at Fifty-first and Cherry Streets, as well as the Nichols Company shopping centers at Crestwood, Prairie Village and The Landing.

Separate from the work of the Nichols Company, the housing in the Country Club District provided a growing community of Kansas City architects with unparalleled opportunities to build reputations. Among those, Kansas City was fortunate to have two architects notable for both their unique and innovative approaches to their respective specialties and the fact that they were among only a few female architects in practice at the time. Nelle Nichols Peters (no relation to J.C. Nichols) was highly successful in the 1920s when her signature projects—apartment buildings—were so popular. Her Country Club District contributions include some of the apartment buildings in the "Poet's District" on the west edge of the Country Club Plaza: the Robert Louis Stevenson, the Mark Twain, the Oliver Wendell Holmes and the Robert Browning. Peters was also the architect for one of the Mission Hills homes on Overhill Drive. The architect Mary Rockwell Hook not only worked in the Country Club District but lived there as well. Hook, whose focus was primarily single-family homes, was known for both her work in the Italianate architectural style and for floor plans that, as she said, "bring the outdoors in." She designed seven of the large homes in the exclusive Sunset Hill subdivision, including her own home and one for her parents. Nearby Rockwell Drive and Rockwell Bridge are named for the family.

Of all the notable architectural projects in the Country Club District, Corrigan House is among the most well known and certainly one of the most architecturally important. The home's original owner, Bernard Corrigan, had a dubious local reputation, earned largely in the 1880s. Corrigan and his three brothers were contractors who had made their fortunes building the city's early infrastructure. The Corrigans owned and operated the city's largest streetcar system, and Bernard Corrigan was also police commissioner. The Corrigans allegedly operated the city's pre–Pendergast era political machine. *Kansas City Star* publisher William Rockhill Nelson spent more than thirty years using his paper's editorial columns to call out the unethical practices of the Corrigans and lobbying for improvements to the transit

The southeast-facing entryway of Corrigan House, designed by Louis Curtiss and listed on the National Register of Historic Places, was one of the first homes built in Sunset Hill in 1914. *Library of Congress, Historic American Buildings Survey.*

system. In 1912, during his waning years, Bernard Corrigan commissioned the house on Fifty-fifth and Ward Parkway before Nichols had expanded the Sunset Hill development to that part of the district. Corrigan died just months before the massive house was completed.

The popularity of the house endures not because of its ownership but because it is among the best work of Kansas City's most famous architect of the era, Louis Curtiss. Curtiss has often been referred to as the "Frank Lloyd Wright of Kansas City," a claim that is reflected in the design of Corrigan House. The house is distinctive for many reasons. In terms of style, it is an excellent example of the Prairie style, with its low-pitched roof and horizontal banks of windows with strong vertical details. It is among the first houses in Kansas City to make use of reinforced concrete and is built on a steel frame covered with concrete, with its outer walls encased in limestone from Carthage, Missouri. Its most dramatic exterior feature is the nearly two-story Art Nouveau stained glass next to the main entrance, but the stained-glass motif is repeated in other exterior windows, as well as on interior details. The entryway is also the most dramatic interior feature, with decorative inlays to the granite

staircase and the flooring and a massive clock built into the staircase wall. Along with the homes of Mary Rockwell Hook in Sunset Hill, the Corrigan House is among the Country Club District properties listed on the National Register of Historic Places.

AN OUTDOOR MUSEUM:
PUBLIC ART IN THE DISTRICT

J.C. Nichols had a lifelong love affair with the cities of Europe. His first trip when he was twenty left him with a fascination with their form. His trips in the mid-1910s to study how commercial areas fit into the scheme enhanced his understanding of how cities worked and inspired his thinking about their architecture. But every trip—and over his lifetime, there would be many—impressed on him how public art made a dramatic difference in the character of a place. The sculpture and fountains that he found in public squares and parks all across Europe brought art out of museums and into the community. And more importantly for the Country Club District's purposes, he noted that while a large art installation or grand fountain created a dramatic effect, the small decorative elements found in corner gardens, along promenades or tucked into little courtyards were landmarks and sources of pride for their respective corners of the community. In a speech in 1937, Nichols said:

> [W]e endeavored to make our property sort of an outdoor museum, and have installed in some two hundred locations, garden ornaments comprising fountains, vases, statues, well heads, and other objects of art. They give distinctive tone to the neighborhoods, creating a certain pride in the hearts of the dwellers, stimulating an aspiration to further beautify their own premises.

As early as 1920, Nichols began announcing plans in the *Country Club District Bulletin* to install art objects around the district. A second announcement in the November 1922 edition recounted some of the specifics of Nichols's acquisitions and hinted at the effect residents might expect, including a picture of an elaborate marble garden pavilion. "Visiting the leading European collectors of antique and modern garden ornaments," the *Bulletin* reported, "Mr. Nichols purchased more than a hundred pieces of marble, including pavilions, fountains, vases, columns, sun dials, well curbs, statues,

Left: Installed in 1929, the "boy and frog" at 302 Nichols Road is a favorite among visitors to the Country Club Plaza. Seen here in 1933 on the edge of an open parking lot, today there are retail shops around the figures. The bronze was purchased from Nichols's favorite, the Romanelli Studio in Florence. *Wilborn & Associates.*

Below: Ward Parkway at Sixty-eighth Terrace, looking south, circa 1930. This small "boy and fish" fountain was installed well in advance of most of the housing. *Wilborn & Associates.*

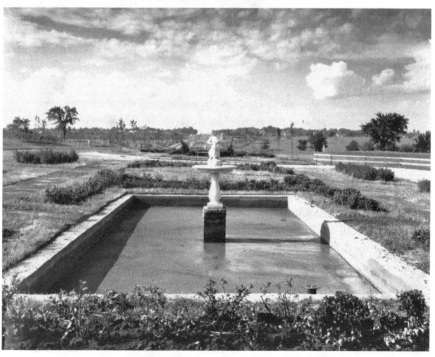

benches and many other beautiful features." Displaying his taste for the finer things, the article continued, "[Mr. Nichols] considers the Italian fountains of Carrara and Tuscan marble particularly appropriate for the District."

The original one hundred pieces Nichols had procured by 1922 multiplied over the life of the Country Club District. Based on his later speeches and interviews, the total number of pieces had grown to two hundred by 1937, and the cost he estimated in 1945 to be $500,000 grew to $1 million, according to a 1969 auto tour brochure the Nichols Company published. The Nichols Company deserves tremendous credit for purchasing and placing those objects around the Country Club District. But once placed, their future maintenance became the responsibility of others. Those that were placed in public areas on the Missouri side—primarily in the long, graceful median of Ward Parkway—became the responsibility of Kansas City's Parks Department. Those placed in small traffic islands, at gateway intersections and in neighborhood pocket parks became the responsibility of the respective homes association. The fact that so many of the original pieces have survived or, when damaged or stolen, been replaced by works of comparable value is a credit to those organizations.

Nichols gathered his pieces several ways. Some have claim to being legitimate antiquities. Others were replicas produced by Italian artisans working with the same materials mined from the same quarries as the originals. Others were simply high-quality versions of relatively common lawn ornamentation. Though Nichols brought back pieces from all over the world, perhaps the most well-known name associated with the best of the artisan work is the Romanelli Studios in Florence, Italy. The studio traces its roots to the work of Lorenzo Bartolini, one of the greatest Italian sculptors of the nineteenth century. His best student, Pasquale Romanelli, took over the studio after Bartolini and became the first generation in a distinguished lineage of Italian sculptors to operate the studio. Nichols would have likely worked with Pasquale's son Raffaello (1856–1928) and Raffaello's son Romano (1882–1968). J.C. Nichols honored his relationship with the Romanelli family and its studio by naming one of his subdivisions Romanelli Gardens and by giving the Romanelli name to the shops at the southwest corner of Gregory Boulevard and Wornall Road.

The 1969 auto tour brochure published by the J.C. Nichols Company, *The Outdoor Art of the Country Club District*, is the primary source here of historical data on the art installations that the Nichols Company placed throughout its subdivisions. According to that account, following J.C.'s death in 1950, very little information was available in Nichols Company records about the

purchases. This accounts for the list being well short of comprehensive. Still, the brochure provides a summary of the background of some of the district's most well-known pieces, which is the basis for most of the descriptions that follow. These descriptions include only those pieces located in the district's residential areas, not its commercial centers. Generally, pieces selected for description here are either wholly or largely intact and similar to their original.

Seahorse Fountain, Meyer Boulevard at Ward Parkway

Located in the middle of Meyer Circle, the Seahorse Fountain is among the most popular and best known of the Country Club District's art installations and one of Kansas City's iconic images. The fountain takes its name from the three sculptured seahorses that support the fountain's bowl structures. The original fountain, crafted from Carrara marble, dates to seventeenth-century Venice. The Nichols Company purchased it from salvage in the

Installed in the early 1920s, the Seahorse Fountain (more commonly known as the Meyer Circle Fountain) sits near the center of the original Country Club District, on the axis of two of its most prominent streets, Ward Parkway and Meyer Boulevard. This photo from about 1925 shows the Nichols Company's General Grounds office at the time, just to the right and behind the fountain. *Wilborn & Associates.*

early 1920s and then constructed the circular pool and the central pedestal. Company records do not provide a cost figure but do mention that at the time of its installation, "it represented the costliest object of art to be purchased by the firm." The Kansas City Parks Board took possession of the Meyer Circle property and the statue in 1925. The Seahorse Fountain is not entirely original. In 1960, vandals destroyed the top statue, and a new figure was crafted to replace it.

Bronze Eagle, Ward Parkway at Sixty-seventh Street

At fifteen feet high from the base of its pedestal, and with a wingspan of fourteen feet, the Bronze Eagle in the Ward Parkway median near Sixty-seventh Street is one of the largest and most impressive of the district's statuary. Although it is a well-known and much-loved piece, it is often overlooked, for its bronze construction blends into the surrounding landscape. The detail with which the eagle is depicted—ready for flight and ready to swoop down on its prey—makes it the district's most dramatic sculpture. The Nichols Company records indicate that the eagle is Japanese and date it to the eighteenth century, where it originally stood in the courtyard of a Japanese temple. The Japanese Embassy imported the bronze to display in the 1903 St. Louis World's Exposition. From there, it found its way to a New York art dealer, who sold the piece to the Nichols Company. The eagle was installed and presented to the city in 1935. Originally, the eagle had golden eyes. Those were destroyed by vandals sometime after World War II. The eagle was included in a *Life* photo essay, shot by photographer William Vandivert in 1938. In that shot, the statue stands on open ground, with no evidence of any housing yet built around it.

Statue Groupings, Ward Parkway at Sixty-ninth Street

Together, these pieces demonstrate how effectively the Nichols Company placed relatively small and less dramatic pieces to their greatest effect. In this grouping, pairs of statuary pieces are located on either side of Ward Parkway and anchored by a third piece in the parkway's median. The west sidepieces include a wellhead in the foreground and, in the background, two statues depicting Diana, goddess of the hunt, on the left and Hippocrates, father of medicine, on the right. Nothing is recorded of the history of the

wellhead. The Diana statue is carved from Carrara marble. Both statues date to the eighteenth century, and both were reclaimed from an estate in Massachusetts. On the east side of the parkway, the pattern of one in front, two behind is repeated. This time, it's a carved marble vase from Pisa, Italy, in the foreground, while in the back are two marble statues of Greek maidens. The statue on the left is identified as Hebe, goddess of youth and spring, a reproduction of an original by the early nineteenth-century Italian sculptor Antonio Canova. According to Nichols Company records, nothing is known about the second statue. The anchoring piece in the center of Ward Parkway is a small reflecting pool, which originally held a fountain of a boy holding a fish, fashioned from Carrara marble.

Antique Venetian Fountain and Wellhead, Brookwood Road (Sixty-first Street) and State Line

These two pieces were installed in a sunset ceremony on June 24, 1923. The installation was symbolic, with one piece on either side of State Line Road and those in attendance representing the two adjacent subdivisions: the Mission Hills Homes Company from the Kansas side and Stratford Gardens as the Missouri contingent. The Mission Hills piece was a three-hundred-year-old Venetian fountain that J.C. Nichols had procured from a London art dealer. The Stratford Gardens piece was undated but also from Venice and originally served as a cistern and a communal source of drinking water for its neighborhood.

Japanese Lanterns, Wyoming at Sixty-fourth Street, East Side of State Line

The Japanese lanterns were originally purchased in the early 1900s by a New York lawyer who served as a financial representative of the Japanese government. Their price at that time was $5,000. Purchased by the Nichols Company in 1940, the pieces are relatively late arrivals to the Country Club District collection. The brochure comments that their value relates to "their size, repousse decorations and artistic scroll work" and that at the time of their purchase, they were considered "the most important Japanese lanterns in this country."

THE COUNTRY CLUB DISTRICT AESTHETIC

Travertine Stone Fountain, Wornall Road at Sixty-ninth Street

This fountain is noteworthy for several reasons. First, it was sculpted by a member of the Romanelli family, Romano Romanelli, specifically to be presented to the Romanelli Gardens neighborhood, where it serves as a gateway feature at Sixty-ninth Street. While most of the district's public art is made of Carrara and similar marble, this piece is made of travertine, a material that is created by limestone deposits from springs, more commonly found in building construction. The fountain was the subject of one of the many Nichols Company promotional postcards. In the postcard, the fountain is shown near the intersection with Wornall Road. In later years, the fountain was relocated a few feet west, as the centerpiece of a neatly arranged neighborhood parklet. In the brochure, the Nichols Company repeatedly used the term "parklet" to refer to small green spaces that ranged from parcels too small to be true parks to small traffic islands.

The Verona Columns, Mission Drive, Ensley Lane and Overhill Road

The Verona Columns are another of the district's signature sculptural landmarks, particularly for the Mission Hills area. The columns that frame the parklet's background are primarily crafted from a pinkish marble unique to the quarries of Verona, Italy. Each column weighs in excess of three thousand pounds. The approach to the columns features a long, shallow reflecting pool with a fountain. According to Nichols Company records, the parklet was built over an existing small creek, and the two homes on the hill behind the columns were built after the parklet was completed and designed in the Italianate style to complement the columns.

Antique Wellhead, Tomahawk and Seneca Roads

One of the district's least imposing sculptural pieces is one of its greatest finds. The antique wellhead at Tomahawk and Seneca Roads in Mission Hills sits in a small traffic island parklet. Nichols Company records do not definitively date the piece, nor do they identify its country of origin. At the

In this view taken in the 1950s, the design of local landscape architect S. Herbert Hare is made complete by the mature trees and other plantings around the Verona Columns in Mission Hills. The park was built in 1925. *Wilborn & Associates.*

time of its purchase, J.C. Nichols invited Paul Gardner, then the director of the Nelson Gallery of Art, to examine the piece. Gardner saw elements of Romanesque and Byzantine designs in the carvings on its surface and attributed it to the Lombard region of thirteenth-century Italy.

As each of the art objects was installed in the district, invariably there was an announcement about it in the *Country Club District Bulletin*. Predictably, there would be an affirmative statement about the Nichols Company's confidence in district residents to respect and protect the pieces and be inspired by their presence. Despite Nichols's personal belief that his residents would value these pieces, the 1969 art tour brochure also documents the extent to which vandalism had taken its toll on many of the pieces, including those that happened even in the earliest days of their placement. Still, despite

the vandalism and having dealt with nearly fifty years of maintaining and replacing the statues, the 1969 brochure encouraged visitors and residents alike to continue to enjoy the art up close. Its closing invitation still stands: "In viewing the art, please park your car and walk around and touch the individual items—feel the fine texture of the marble and the delicate tracings. Visualize the skill and time required to create them. You will be amazed at the delicate and charming details revealed by a close inspection."

A Lost Wilderness

There is one aesthetic element that J.C. Nichols held in high value as he planned the Country Club District, one that did not prove to be permanent. Nichols's belief in the value of nature wasn't limited to encouraging residents to plant trees and gardens or taking advantage of the natural contours of the landscape in his subdivision planning. Early on, Nichols and his staff, particularly his landscape architects, incorporated plans for hiking trails, riding paths, lakes and picnic spots into the master planning for the district.

Nichols was determined to keep the "country" in the Country Club District, but his motives were likely mixed. There's certainly a lot of evidence that love of nature was a personal value of J.C.'s. He also capitalized on nature in his promotion of the Country Club District. One well-circulated photo of J.C. Nichols and his family shows them at one of the district's picnic areas having a cookout. But his interest in developing these rustic touches for the district might just as easily be attributed to savvy land management. From his earliest years, and certainly by the housing boom of the 1920s, Nichols's acquisition of property far outpaced his housing development. He had large tracts of land that wouldn't be developed for years, and his impulse toward enterprise would have him make use of any vacant acreage. If the land wasn't yet able to provide the value of new housing, Nichols saw it could augment the value of his existing subdivisions as amenities. And in its unimproved state, that amenity was nature.

Birding was a popular pastime of the era, as were many activities associated with nature education. The *Country Club District Bulletin* often used its pages to announce bird-watching contests and birdhouse-building contests and to provide tips on bird feeding and bird feeders. Its devotion to all things bird related had no limits and could at times rise to the level of

THE COUNTRY CLUB DISTRICT OF KANSAS CITY

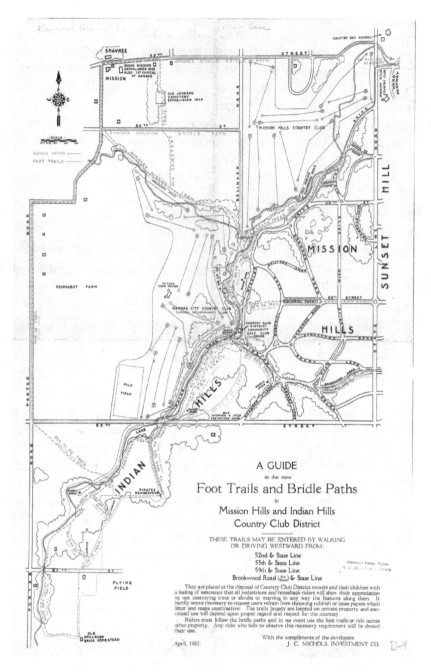

In 1922, the Nichols Company issued *A Guide to the New Foot Trails and Bridle Paths in Mission Hills and Indian Hills*. The bridle path also connected to the Parkview Riding Academy, which was located on the current site of the Country Club Plaza. *Missouri Valley Special Collections, Kansas City Public Library, Kansas City, MO.*

fervor. "You cannot be a friend to both the bird and its enemy the cat. It is hard to conceive that any tender-hearted person would harbor a house cat when it will deliberately destroy the little birds," admonished a May 1919 piece. Right below was this threat for the district's youth: "Any resident of the district discovering boys shooting or throwing rocks at the birds should immediately report it to the Police Department." Later in the same issue, an explanation was offered that "we are purposely delaying the mowing of vacant lots and ground to let the little [meadowlarks] get strong enough to take care of themselves. If we would mow the grass now we would destroy many of the birds." In a June 1922 issue, under the title "Owls and Hawks Prey on Defenseless Birds," natural predators were put on proper notice: "Many birds in the District are falling victims to the vicious hawks and owls. Birds are far more valuable than these unfriendly creatures, and the only way to protect the birds from them is to exterminate all owls and hawks—so whenever we see an owl or hawk, let's 'shoot to kill!'"

The Country Club District system of hiking and riding trails was one of its most ambitious attempts to marry the natural setting to suburban development. In 1922, the Nichols Company published a map: *A Guide to the New Foot Trails and Bridle Paths in Mission Hills and Indian Hills.* The Kansas side was the logical place for these features. The area was still unincorporated, and one of the footpaths fit neatly along the boundaries of the Mission Hills Country Club and the future site of the Kansas City Country Club, then called the Community Club. Another path looped about a half mile to the northwest, circling the old Shawnee Indian Mission (one of J.C. Nichols's favorite civic projects) and running through the old Johnson family cemetery nearby, both of which provided points of interest for hikers. The southern trail provided its own interesting features. There were springs, old rustic bridges and picnic ovens for campfire cookouts with friends and family. There were places that hinted of mystery and history—an old Santa Fe freighters campsite, the old Spillbush Homestead and a spot on the map labeled "Pirates Rendezvous."

On the map, each trail was labeled with two names—one providing a general description and another in the style of summer camp names, implying vague and clichéd connections to the area's Shawnee tribes of the past. Thus, the Valley Trail that wound below Mission Drive by the golf course was also named "Owa-Ko-Pe Trail." The descriptive names are more charming and, in some cases, more intriguing: Firefly Gulch, Happy Bird Trail, Difficult Trail, Owl Pass, Close to the Campfire Trail, Sunset Trail and Beautiful Plain Trail, to name a few. The Shawnee Mission Bridle

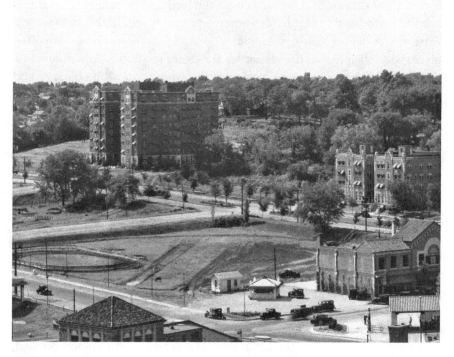

The days of the Parkview Riding Academy are numbered in this photo, circa 1925. The riding track is visible at left, even as the apartments, filling stations and retail stores of the Country Club Plaza are being constructed around it. *Wilborn & Associates.*

Path was the name of the large loop around the whole area, running from Ward Parkway on the north near Pembroke School, west to Mission Road (called Porter Road at the time), south to just past Sixty-seventh Street and then back to the east and State Line Road.

The map indicates that the bridle path connected back to the east at the "Riding Academy." Parkview Riding Academy was established in 1915 on what would become the western edge of the Country Club Plaza, near Forty-eighth Street and Pennsylvania Avenue. It is possible that J.C. Nichols or the Nichols Company was involved in the startup of the riding academy. Nichols had been working nearby in Bismark Place since 1905 and had struggled with existing nuisance businesses like the brickyard diminishing his investment. He had also been actively acquiring property around the future plaza site since 1912. No records were found that directly linked Nichols or his company to a direct interest in the riding academy, but it would have been in keeping with the kinds of partnerships he formed when he went courting

a school, a parish or a business into locating in his Country Club District. In an announcement in the October 1915 *American Breeder* magazine, Roy L. Davis of Marshall, Missouri, is credited with establishing the Parkview Riding Academy and named as its operator. Commenting on those who would question whether a riding academy still had merit in the coming age of the automobile, the magazine added, "This may seem like a 20-years-ago-item to some, but it isn't, and moreover, a good rider mounted on a good saddler will beat any safe speed in an auto for attracting attention—and that is what a lot of good money is spent for."

Just south of the Community Club course, the Nichols Company constructed Lake Hiwassee in 1924 by creating a dam along Brush Creek, where it crossed Sixty-third Street and Indian Lane. Every footpath in the area led to the lake, and the bridle path ran by it as well. Lake Hiwassee was the site of one of the district picnic ovens, and it was across the road from and in sight of the polo field that at one time sat on the southwest corner of the Community Club property. Nestled among rolling hills, with a wooden bridge to reach a small island in the center, Lake Hiwassee was a lovely spot. With more golfers than residents nearby at this point, the area would have seemed every bit the countryside Nichols wanted to capture.

This postcard depicting Lake Hiwassee on Sixty-third Street near Indian Lane dates from the 1920s. The lake was built and maintained by the Nichols Company for the enjoyment of district residents. *Author's collection.*

131

He could not capture it for long. His faith in his residents and the public at large to respect and maintain these improvements was apparently misplaced. The November 1927 issue of the *Country Club District Bulletin*, the following piece under the title "Picnic Ovens Sadly Abused":

> *Removal of the picnic oven from the island on Lake Hiwassee became necessary on account of the abuse of the privilege by picknickers who, through ignorance or carelessness, failed to appreciate the efforts of the Nichols Companies to give them this delightful opportunity for outings. On this island in Lake Hiwassee (the very beauty of which should gain the respect of those who held picnics there), trees, shrubs and evergreens were broken down and used for firewood. Careless and inconsiderate picnic parties, ignoring the common principles of outdoor etiquette, likewise the signs asking them to clean up their litter, not only left it lying about, but ruthlessly threw trash and paper into the water of beautiful Hiwassee. And so another illusion is gone. Somehow we felt sure that here would be one spot where picnickers would at least show consideration for private property. Fortunately, the abuse is not quite so great at the other picnic ovens in the District. These ovens will be allowed to remain yet awhile—but unless the persons who use them show a decent regard for the surroundings, it will be necessary to remove all the picnic ovens from the entire Country Club District.*

Evidently, the general disregard for the surroundings continued. The company did construct a second lake, the surviving Willow Lake, also known as Eisenhower Lake just south of Sixty-third Street at Ensley Drive. Lake Hiwassee, however, was filled in 1944, when the creek's heavy silting caused damage to the dam. Eventually, the foot trails and bridle paths were casualties as well. But in an article J.C. Nichols wrote for the *National Real Estate Journal* in 1938, when he had not yet completely abandoned the trails, the lake or the picnic ovens, he recognizes that the real death knell for these amenities is the ever-expanding Country Club District subdivisions. Nichols writes:

> *We have used many measures to create interest in our subdivisions, such as the building of picnic ovens in some of our nearby vacant ground. However, after homes were built near these picnic ovens as a rule they became a menace and we had to remove them. We have also put in houses for Campfire Girls or Boy Scout activities which are all right as long as they are remote from homes, but as the subdivision builds up around them we*

have found they often become objectionable. We have laid out many bridle trails through our property which was all right as long as our ground was vacant, but when these bridle trails became near homes, the litter along them was objectionable; the riders using the trails early in the morning awakened sleepers; and there was some objection to rough language used by people using the trails which was heard by children in the neighborhood. We found it very difficult to maintain a bridle trail through a well built up area.

At this period in the district's development, the early 1920s, the city's park plan was in place, but parks were playing a relatively minor role in the layout of the Country Club District. The Nichols Company had built a few of its own parks. Arbor Villa in the Armour Hills subdivision was one, the sort of parklet the company had in many of the subdivision plans, even though few others were ever built. Arno Park in Romanelli West is similar in style and scale to Arbor Villa but with fewer amenities. Mill Creek Park on the eastern edge of the Country Club Plaza had been there since 1908 but is much larger and not inside the subdivision areas. The curvilinear pattern of the streets created triangular-shaped blocks, which in turn created remnant pieces of property in the center of those triangles where house lots didn't quite meet. The Nichols Company tried to turn these isolated middle lots into private parks for the adjoining residents. But in a 1938 speech, Nichols admitted failure:

With one exception [the interior parks] *have all proved unsuccessful. They encourage neighborhood quarrels; are very hard to police; and families who did not have children objected to the noise of the children playing in the rear of their homes. We generally tried to protect these interior block playgrounds and parks by prohibiting any detached garages along the borderlines, thereby improving the view from the garden side of the homes across the interior space. We found that we had to contend with much intrusion into these parks by rough and unruly children and adults who would impose upon the purposes of the park. Several of these interior block parks have been completely abandoned although we originally provided some of them with wading pools; pergolas; teahouses; concrete sandboxes, and other playground equipment.*

Although not technically a park, the boulevard system operated as a sort of park, or at least a public space for outdoor recreation. In its original layout, Ward Parkway was particularly well suited for parklike activities. In

Before concrete was used to try to tame it, the banks of Brush Creek through the Plaza offered broad, tree-lined parklike settings. Seen here is William Dunn, the city's first director of the Parks System, in 1932. *Missouri Valley Special Collections, Kansas City Public Library, Kansas City, MO.*

the beginning, there were long, winding paths laid out for the convenience of the neighborhood or anyone who wanted to walk the length of the parkway. The paths passed by several long, shallow pools suitable for sailing model boats in the summer and ice-skating in the winter and by benches offering places to sit in the shade and watch the birds. In later years, much of that infrastructure was removed, and while a few statues and pools remain, the modern Ward Parkway is primarily green space.

It was by happenstance, not planning, that the Country Club District gained its largest park, Loose Park, at Fifty-first Street and Wornall Road. As Hugh Ward's widow, Vassie Ward (now) Hill had retained ownership of the property of the Kansas City Country Club in the Sunset Hill subdivision. The country club had already relocated to its new home in Mission Hills, and Mrs. Hill had always envisioned that, once shed of the club as a tenant, the Sunset Hill subdivision could be expanded onto that land. Her timing was poor. The opportunity for building didn't

The Shelter House at Loose Park has changed since this scene in 1936, but the pergola feature remains. The shelter sits at the north end of the park. *Missouri Valley Special Collections, Kansas City Public Library, Kansas City, MO.*

come together until 1926, too far into the housing boom for there to be the kind of demand needed to justify development of the upper-income homes for which Sunset Hill was known. Once again, J.C. Nichols conceived a plan to suit many purposes and set about to broker the deal. He contacted Ella Loose, the widow of Jacob Loose, founder of Kansas City's own Sunshine Biscuit Company. He suggested that Mrs. Loose purchase the Ward estate property to create a park to honor her late husband. It was an inspired idea, more inspired than Nichols realized at the time. Not only has Loose Park become a signature park for the Country Club District, but it is also a favorite gathering spot for much of the city, with its extensive rose gardens, picnic tables, duck pond and a full complement of playgrounds and tennis courts. Perhaps most importantly, by saving the property as a public park, it was also saved as a site of national importance—the central site of the Civil War's Battle of Westport.

Innovation by Design

J.C. Nichols was, first and foremost, an expert salesman. He was adept at using his powers of persuasion to convince banks to invest in, powerbrokers to champion and buyers to believe in the Country Club District. Deed restrictions demonstrated stability to investors. Community features enchanted potential residents. Making the district a showcase for the modernization of America—new ideas, innovations, technology—kept the Country Club District in the forefront of housing and community development discussions across the country.

The Nichols Company's use of the area's rail system is an early example of how technology of the day played a role in the district's development. In 1906, Nichols and other investors bought the old Dodson Dummy Line railway that ran south out of Westport through Waldo to the small rail hub community of Dodson. By controlling the rail line, they intended to

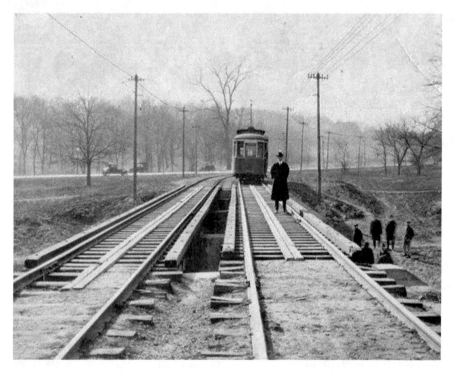

A city worker stands on the trestle above Brush Creek on the Sunset Hill streetcar line as it heads south toward Sunset Hill, circa 1925. Though service became less regular around 1915 due to lack of ridership, the line remained until after World War II and then became a bus line. *Missouri Valley Special Collections, Kansas City Public Library, Kansas City, MO.*

eliminate the nuisance of freight traffic and use the rail for a streetcar line. Though Nichols was never completely successful in realizing all his goals for that line, the Country Club Line did become the most successful and long-lasting route in the city's streetcar system, running from 1905 to 1957. The Country Club Line served the eastern side of the district, but Nichols thought there would be more demand for streetcar service than the one line could accommodate. He pushed for, and successfully secured, a second line: the Sunset Hill Line. As part of the development plan between the Ward family and the Nichols Company, in 1909 the Ward estate paid the Metropolitan Street Railway Company (the same company that operated the Country Club Line) $60,000 to extend another line running south and west out of Westport, connecting with Ward Parkway near Brush Creek and then following the parkway farther west and south toward the Sunset Hill and Mission Hills subdivisions. The Metro completed the project in 1910. By 1913, however, the Metro was already starting to reduce service on the Sunset Hill Line. The Metro claimed there were too few patrons. In the wealthy neighborhoods along Ward Parkway, there seemed to be little need for public transportation. The new automobile was king of the road.

In the 1920s, automobiles might have been ruling the roads, but airplanes ruled the skies. Nichols thought the Country Club District should have its own "flying field." In the early days of aviation, a flying field was all that was needed—an open, flat space that might or might not have a graded or paved surface for landings and takeoffs or any other infrastructure. The district's flying field would not be the area's first. There was plenty of interest in flight in Kansas City, not the least of which came from local business interests. Nichols no doubt shared the same instinct that aviation offered huge potential for the country's economic future. In 1918, the United States government began airmail service. Though still in its infancy, this would have been enough to interest J.C. Nichols in how air service might benefit the Country Club District.

In February 1922, the Flying Club of Kansas City, a group of local enthusiasts, met downtown in the Hotel Baltimore. Their agenda for the day included a discussion regarding whether to lease property for a flying field. The April 1922 issue of *Aerial Age Weekly* made an extensive report of that meeting, as well as the events that had transpired in the three months since. At the meeting, J.C. Nichols was present to suggest a site for the field. He proposed his property at Sixty-seventh Street and Belinder Road, which at that time was still well beyond the boundaries of his current subdivision projects. The article reported that the local club signed the lease and

christened the field the American Legion Flying Field. The lease was signed just three days after the meeting. The new field, the article went on, was already generating impact. Early aviation manufacturer Huff-Daland would be opening a plant in Kansas City. Another well-known aviation company of the time, H.H. Steely, had opened a school to train pilots. Laird Aviation of Wichita wanted to connect that city with Kansas City through regular passenger service. The *Aerial Age Weekly* article also mentioned temporary hangars already on site, additional permanent hangars still to be built and a significant amount of infrastructure to be put into the site.

This rapid expansion may have been too much too soon for J.C. Nichols's comfort. If he was beginning to recognize that what some saw as amenities, others saw as nuisances, he might have anticipated that if he allowed the flying field to continue to grow, he would permanently and adversely affect the value of some of his Country Club District property, forever limiting the level of acceptable development. It is also known that this was the period in which civic leaders began taking a larger and longer-term approach to establishing Kansas City as an aviation center. A scant four months after that first article on the Flying Club of Kansas City and its American Legion Flying Field, *Aerial Age Weekly* reported in its August edition that the club would be moving to a new location. That site would be farther out, in Raytown near Blue Ridge Boulevard. The club planned to let its lease expire in November 1922. So, for a brief period of no more than six months, the Country Club District had its own flying field, which was the center of Kansas City's aviation industry.

The year 1922 was also the one in which the Nichols Company built the first electrical house in Kansas City. Located in Armour Hills near Sixty-fifth Street and Linden Road, the house was featured on the cover of the October 1922 *Country Club District Bulletin*. The design was by the Nichols Company's lead architect, Edward Tanner, who was also at that time working on plans for the Country Club Plaza. The selling points the article used were anything but subtle: "Tucked away in every woman's heart is her ideal of a household conducted with instruments more speedy than human hands. And the woman who learns of the service flowing through the wires which lead to the simple-looking button on her wall, is on the threshold of a new life."

Several years later, in 1941, Tanner was also the architect for a housing innovation of a very different type: defense housing. J.C. Nichols had been deeply involved in the early war effort as a regular employee of the National Defense Advisory Commission (NDAC). Nichols had worked on national level projects in the 1930s, although mostly around the topics of

The October 1922 edition of the *Country Club District Bulletin* featured an article about this, the first electrical home in Kansas City, built in the Armour Hills neighborhood and designed by Nichols Company architect Edward Tanner. *Missouri Valley Special Collections, Kansas City Public Library, Kansas City, MO.*

planning, real estate and public works. But he had earned a reputation in Washington, D.C., as a first-rate manager and executive. The offer to head up the Miscellaneous Equipment Division of the NDAC came with a special incentive: being in Washington would give Nichols a chance to lobby for more defense contracts for the central states and Kansas City in particular. Nichols worked at NDAC for only a year, during which time a significant number of defense contracts were secured for those in the Kansas City area, including the Remington Arms plant in Kansas City and the Sunflower Ordnance plant in nearby DeSoto, Kansas.

Nichols had never liked government-led housing development; he felt the private market was better suited to offer a cost-effective, quality product for the country's low-income population. But defense housing was different. There was an overwhelming need for housing for defense workers, including those in the military and their spouses. The needs were everywhere, not just near military bases, and with the nation growing ever more involved in the coming war, demand was increasing exponentially. Likely a show of support for the war effort to which he had already devoted so much of himself, these two model houses were an attempt to translate

the tight budgets allowed by the Defense Department into quality housing, Country Club District style—at least as best as could be done.

The houses were featured in the November 1941 issue of *Architectural Record*. The two houses at 4924 State Line Road and 5424 Norwood Road were small, two-bedroom units on a square floor plan. As the article stated, "There will be difficulty in attaining the desirability of these two Nichols houses within the $6,000 maximum for house and lot permitted in the priority order. Much can be done to maintain the subdivision's standards by leaving out, for the present, all possible extras."

Extras weren't left out of the home that came to be known as the "Blandings' Dream House." The Nichols Company had built plenty of model homes in its time, but the last one it built during J.C. Nichols's lifetime had a unique approach to demonstrating the innovative side of the Nichols Company—specifically, how to build a quality home for less. In 1948, actors Cary Grant and Myrna Loy appeared in the comedy *Mr. Blandings Builds His Dream House*. Based on a 1946 magazine article, the story followed a contemporary couple who moved to the suburbs outside New York City and built a home. What started, in the story, as a $20,000 project ended up costing the fictional Blandings family more than $50,000. The magazine article had tickled the imagination of several large developers, including J.C. Nichols. To take advantage of the publicity surrounding the movie's release two years later, Nichols and several other developers built homes as near as possible to that described in the story. In the Country Club District, that meant a standard two-story Colonial just off Ward Parkway near Meyer Circle—and for considerably less than the figure in the story. It was proof to the American—or at least the Kansas City—public that quality homes could be had for a reasonable amount. When the Nichols model home opened, the public stood in a line down the front walk just to get in.

EPILOGUE

Let's answer the drumbeat and bugle call of our times. Ours is a calling which challenges the souls and red blood of men. It calls for backbone and stamina. Let's gall all chips off our shoulders—throw off our traditional inertia which is resistant to change. Let's not let little things get our goat. Let's steer for difficult ports. Let's not be afraid to set up a distant goal. Let's go home; scan a new horizon; begin to grasp our infinite possibilities, and find happiness in our chosen profession. Let's break down the economic handicaps of our region.
—*J.C. Nichols presentation to St. Louis realtors, "Why I Am in the Real Estate Business," January 1937*

In 1954, after twenty-nine years, Faye Duncan Littleton retired from her position as the first secretary to the J.C. Nichols Homes Associations. A few years before, she'd suffered a fall at her home, and recovery had taken longer than expected. Her job for the Homes Associations had always kept her active, but that was more difficult since the accident. She talked about retiring for a while, until 1954, when she was offered another job as a clerk in the sales department of the Nichols Company. It was familiar territory, since she'd been with the company for almost all of the last forty-one years. Even though technically the Homes Association was separate from the company, her desk had always been in the company's headquarters.

For the most part, it had been a happy forty-one years. Faye had loved her work and all the people she met. Early in 1923, shortly after she had taken the position with the Homes Association, she married Joseph Sanford Littleton.

Their happiness was short-lived. Her husband contracted tuberculosis just three years into their marriage and died in 1930. Faye never remarried, but she led an active and happy life. In 1946, she finally bought a home of her own, in the neighborhood just north of the Country Club Plaza, perfect for walking to her office. In addition to her work for the Homes Association, she had hobbies. Her collections of matchbooks, dishes, swizzle sticks, postcards, salt and pepper shakers, lead pencils and playing cards not only kept her occupied but had also managed to make her something of a minor local celebrity. Her collections had been featured in a number of local newspapers. She gave talks on the Country Club District to civic groups and even contributed an article for *House Beautiful* titled "Is There Something Wrong with Your Neighborhood?" for which she was paid $200. Mr. Nichols himself had invited her to be part of the company entourage that met with the staff from the *Saturday Evening Post* when the esteemed magazine came to Kansas City to do a feature on the district.

But if Faye was wistful about leaving her job with the Homes Association, the job as clerk for the Nichols Company was just the right tonic for that. For although her desk might be sitting in the sales department, Faye was really working on a special project, something she had begun on her own time shortly after Mr. Nichols's death. Faye was organizing one of her collections, what would become a scrapbook of the J.C. Nichols Company and the Country Club District.

J.C. Nichols died in February 1950, after a three-month battle with lung cancer. He would have turned seventy that year. As a major civic leader, Nichols's death was a blow to Kansas City. The newspaper of his long-deceased friend William Rockhill Nelson immortalized him with a drawing depicting his desk covered by a blueprint against a backdrop of Country Club District housing. The drawing quotes in English the epitaph written in Latin on the tomb of the architect Christopher Wren, who is interred in his own masterpiece, London's St. Paul's Cathedral. The Latin is translated, "Reader, if you seek his monument, look around you." That drawing was transferred to a bronze plaque that the Nichols Company had placed on the sidewalk in front of its offices on the Country Club Plaza.

The blueprint in the drawing, J.C. Nichols's plan for the Country Club District, was largely completed by the time of his death. Decades later, J.C. Nichols's passing seems symbolic of a shift in the literal and figurative landscape of the American suburb, not just for Kansas City. World War II was five years in the past by then, and the period of the "baby boomer" had begun. The demand for housing was high again—so high, in fact, that the

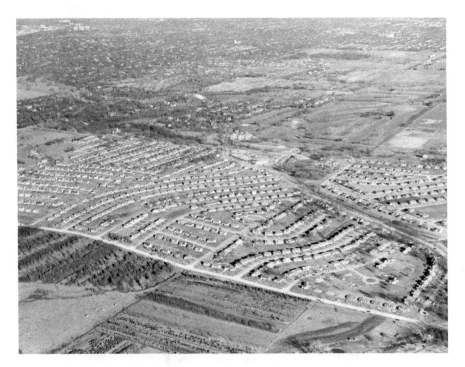

The last of the J.C. Nichols–era subdivisions, Prairie Village came into its own in the 1950s. The first buildings of the Prairie Village Shopping Center can be seen near the center of the photo; to the east (the upper portion of the photo) are the homes and golf courses of Mission Hills and Indian Hills. *J.C. Nichols Company Scrapbooks (K0054 v19p106); State Historical Society of Missouri Research Center, Kansas City, MO.*

Nichols Company was challenged to keep pace. The company's competition was growing, making it hard to maintain J.C.'s strategy of gaining control of adjacent property. The emphasis shifted from residential subdivision construction to commercial development property management. The events of a post–J.C. Nichols Country Club District are worthy of their own story, separate from this focus on its early years. Whether despite or because of these events, Nichols's original vision to build neighborhoods to last one hundred years or more has been realized.

The J.C. Nichols Company continued to dominate the Kansas City real estate market for another fifty years. J.C. Nichols's eldest son, Miller, took over the leadership of the company following his father's death. The Prairie Village subdivision (later incorporated as a city) bridged the pre- and post-1950 eras of the Country Club District's development. Prairie Village maintained the characteristic planning elements and community features of earlier subdivisions, but the housing character typifies the demand of

The commercial section of Nichols's original subdivision, Bismark Place, had significantly declined by the 1970s. Though *A Streetcar Named Desire* was a popular local hangout, it would not have been possible had the Nichols Company been successful in creating deed restrictions in the area in 1905. *Wilborn & Associates.*

the post–World War II era, with smaller homes produced more quickly and on a larger scale. Even so, compared to similar housing of the era, the Nichols Company still managed to produce a better tract-style home than its contemporaries. Miller Nichols retired in 1988, and the company was sold to its employees; then, in 2000, it was sold to Highwoods Properties of Raleigh, North Carolina. Highwoods subsequently sold many of its commercial assets, including the Brookside, Fairway and Crestwood shops. It retained control of the Country Club Plaza. Subsequent ownership of the other previous J.C. Nichols commercial properties became a mix of local and out-of-town ownership.

Nichols's original development in Bismark Place, just south of the Country Club Plaza, would later bear out some of his concerns about developing without proper deed restrictions. Despite its proximity to the Country Club Plaza, one of the nation's most upscale commercial districts, the area (which ceased being called Bismark Place long ago) went through a period of blight in

the 1970s and 1980s. In recent years, large-scale developers have returned to the area, bringing a more consistent level of commercial investment but with a shift toward high-density residential development over single-family homes.

The Country Club Plaza faced its greatest challenge during a devastating and deadly flood that struck the Kansas City area in September 1977. More than fifteen inches of rain fell in the overnight hours of September 12 and 13, hitting the Brush Creek basin particularly hard. The waters rose as much as six feet within an hour, to the horror of shop and restaurant patrons who watched the flood approach from their creekside windows. The disaster caused twenty-five deaths and more than $100 million in damage. The Nichols Company alone had to spend more than $10 million to restore the Plaza, and while that would take months, the annual Art Fair, scheduled for a just a few days after the flood, went on as planned. The flood would be a turning point for the company and for the tone of the Country Club Plaza. The area had lost some of its appeal in recent years. Blight conditions were affecting some of the adjacent areas. The Plaza had long operated as a neighborhood shopping center, and the neighborhood it was serving was not the same as it had once been. Flood repairs prompted the Nichols Company

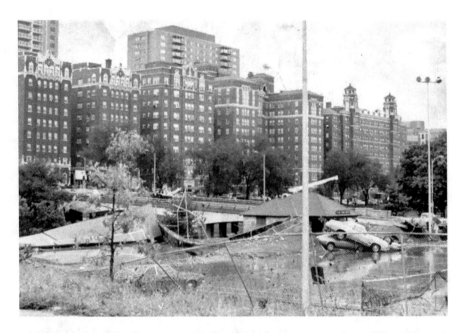

The Country Club Plaza incurred at least $10 million in damages during the 1977 flood that came to be known as the "Plaza Flood." Here, vehicles are found piled up on the Plaza tennis courts when the waters receded the morning after the flood. *Missouri Valley Special Collections, Kansas City Public Library, Kansas City, MO.*

to reinvest, and the iteration of the Country Club Plaza that finally emerged was more upscale than it had ever been. The flood also prompted millions of dollars of public improvements to Brush Creek to prevent the type of flooding that happened that late summer in 1977.

In 1960, ten years after his father's death, Miller Nichols brought a new fountain to the Country Club District, to be dedicated in his father's memory. The fountain would be the largest and most impressive addition to the district's collection of outdoor art. Sculpted in 1910 by French artist Henri Greber, the piece had come from Long Island, New York, where it had been the focal point of Harbor Hill, the sprawling grounds and mansion of mining millionaire Clarence Mackay. The Mackay family's fortunes had waned since those days. The mansion was demolished in 1947, but the fountain was salvaged. Dedicated as the J.C. Nichols Fountain in 1960, it sits at the south end of Mill Creek, the eastern gateway to the Country Club Plaza. The figures include four horse and rider pairings in separate tableaux. Each pairing represents a major world river: the Mississippi, the Volga, the Seine and the Rhine. The J.C. Nichols Fountain has come to be both a trademark image of Kansas City and a favorite community gathering place.

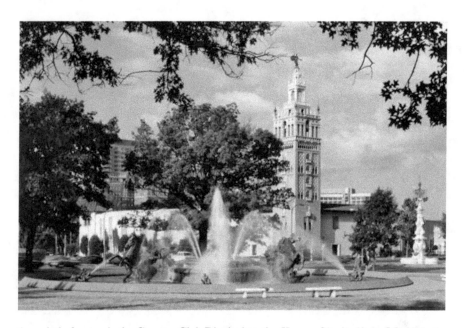

A symbol of not only the Country Club District but also Kansas City itself, the J.C. Nichols Fountain was Miller Nichols's 1960 tribute to his father's legacy. *Missouri Valley Special Collections, Kansas City Public Library, Kansas City, MO.*

EPILOGUE

Faye Duncan Littleton used her final years at the J.C. Nichols Company to their fullest extent. She clipped and pasted all the materials she had gathered over her years with the company, carefully sorting them by date and providing margin notes to make sure the importance of each piece was captured for posterity. She always regretted not starting the project before Mr. Nichols's death, for she knew how much he would have enjoyed helping with it. Instead, she called, wrote to and surveyed everyone she had ever known in her work for the Nichols Company. Her hard work created a treasure-trove of photos, clippings and personal remembrances. She captured it all and carefully attached each to a piece of loose-leaf paper she inserted in one of many oversized three-ring binders. She was still working on the project when she retired from the Nichols Company in 1957 and moved to where her husband had been laid to rest in Tecumseh, Nebraska. In 1962, at the age of sixty-eight, Faye Duncan Littleton returned to Kansas City to present to the Nichols Company twenty-eight volumes of "The J.C. Nichols Company Scrapbooks." Faye's preface to those volumes reflected her devotion to the project, saying simply, "This product of scissors, paste, time and respect for passing events, both great and small, salvages the past and embalms the memory." Members of the Nichols Company staff continued to add to the collection until the company was sold. The scrapbook collection was ultimately presented to the State Historical Society of Missouri (then Western Historical Manuscripts Collection) in 1982. The company's additions of "scissors, past, time and respect" had been worthy of Faye's. Today, "The J.C. Nichols Company Scrapbooks" covers the entire history of the company, from 1910 to 1997. It contains sixty scrapbooks.

ACKNOWLEDGEMENTS

One of the rewards of researching and writing local history is the opportunity to work regularly with a group of individuals and institutions who serve as great resources not only for this work and others of mine but also for almost any writer or historian who works in Kansas City or whose work is set in Kansas City. These include the following:

- The Missouri Valley Room, Central Branch, Kansas City Public Library: The Missouri Valley Room never fails to provide the best information available on the history of the area, with particular strength in the history of Kansas City. Not only does it provide an incredible range of research resources and the skills of a dedicated professional staff, but the library as an institution also provides one of the best venues for writers and historians to share their work with the public. My particular thanks go to senior special collections librarian Jeremy Drouin (my primary research contact for the past three books) and Eli Paul, manager of the Missouri Valley Room, for their special insights and assistance on this and other projects.

- The State Historical Society of Missouri, Kansas City Research Center: In 2010, the University of Missouri–Kansas City turned over the management of its Western Historical Manuscripts Collection to the State Historical Society of Missouri. That center now operates as the State Historical Society of Missouri, Kansas City Research Center. Thankfully, that change has resulted in

even better information and support from the center and its staff. Working out of Newcomb Hall on the UMKC campus, SHSMO-KC is the home of the original copies of Faye Duncan Littleton's "Nichols Company Scrapbooks," as well as a treasure-trove of materials from the J.C. Nichols Company proper. Those who wisely put those corporate records in the hands of SHSMO-KC should be commended. My thanks go to the center's new director, Lucinda Adams, and especially to Nancy Piepenbring, manuscript specialist and researcher extraordinaire.

• Wilborn & Associates: Wilborn & Associates maintains not only its own archive of images dating back to 1921 but also the archives of two other professional commercial photographers operating in Kansas City since the early 1900s: Tyner & Murphy and Anderson Photographers. The result is one of the finest private catalogues of historical images anywhere. Images from the Wilborn & Associates catalogue not only serve as great illustrations for these books, but their quality and detail also make them invaluable as research resources.

In addition to these highly valued perennial resources, I'd like to acknowledge the following individuals or organizations that provided particular technical or background information on specific topics during this project:

Mary Bunten and Norm Friedman
John Carroll, real estate appraiser
Paul Hamilton
Connie Kerdolff, Country Club Bank
Marti Lee, Brookside Business Association
James C. Scott, AIA AICP
Cory Ward, Better Homes & Gardens Real Estate
Doug Wasson, RE/MAX Real Estate

Bibliography

Articles

"Back Talk Column" announcement. *American Breeder Magazine* (October 1915).

"Defense Housing in a Subdivision." *Architectural Record* (November 1941).

"The Forgotten Real Estate Boom of the 1920s." Harvard Business School Historical Collections, Harvard College, 2012.

"J.C. Nichols Builds Again." *Architectural Forum* (October 1934).

Johnson County Herald. "Sees the Birth of Local Communities." April 24, 1963.

"Kansas City Activities." *Aerial Age* (August 1922).

"Kansas City Establishes Airport." *Aerial Age* (April 1922).

McCullough, James H. "He Makes Homes Grow in Waste Places." *American* (March 1923).

McDonald, A.B. "A Home District Beautiful." *Ladies Home Journal* (February 1921).

Nichols, Jesse Clyde. "When You Buy a Home Site." *Good Housekeeping* (February 1923).

"Parkview Riding Academy." *Show Horse Chronicle* (October/November 1917).

Westport Sentinel Examiner. "Westport and Waldo Railway." March 24, 1894.

Wornall, Mrs. John B. "Account of the Battle of Westport and Early Memories of Kansas City." Jackson County Historical Society, October 1961.

BOOKS

Alley, Patrick, and Dona Boley. *Images of America: Kansas City's Parks and Boulevards*. Charleston, SC: Arcadia Publishing, 2014.

Brent, Anne, and Marilyn Ebersole. *A History of Mission Woods*. Mission Woods, KS: Brent/Ebersole, 2012.

Conrad, Howard L. *Encyclopedia of the History of Missouri*. New York: Southern History Company, 1901.

Dodd, Monroe. *A Splendid Ride: The Streetcars of Kansas City, 1870–1950*. Kansas City, MO: Kansas City Star Books, 2002.

Ehrlich, George. *Kansas City, Missouri: An Architectural History, 1826–1976*. Kansas City, MO: Historic Kansas City Foundation, 1979.

Garwood, Darrell. *Crossroads of America: The Story of Kansas City*. New York: W.W. Norton & Company, Inc., 1948.

Grubb, Dawn. *Prairie Village: Our Story*. Prairie Village, KS: City of Prairie Village, 2002.

Haskell, Henry C., Jr., and Richard B. Fowler. *City of the Future: The Story of Kansas City, 1850–1950*. Kansas City, MO: Frank Glenn Publishing Co., Inc., 1950.

Jackson's Real Estate Directory. Kansas City, MO: Jackson Publishing Co., Inc., 1918.

Kansas City, America's Crossroads: Essays from the Missouri Historical Review, 1906–2006. Columbia: State Historical Society of Missouri, 2007.

Mayo, James M. *The American Country Club: Its Origins and Development*. Newark, NJ: Rutgers University Press, 1998.

McAlester, Virginia, and Lee McAlester. *A Field Guide to American Houses*. New York: Alfred A. Knopf, 1986.

McCandless, Perry. *A History of Missouri*. Vol. 2, *1820–1860*. Columbia: University of Missouri Press, 1971. Reprint, 2000.

Moberly, Jane, and Nancy Harris. *A City Within a Park: One Hundred Years of Parks and Boulevards in Kansas City, Missouri*. Kansas City, MO: Lowell Press, 1991.

Monchow, Helen C. *The Use of Deed Restrictions in Subdivision Development*. Chicago: Institute for Research in Land Economics and Public Utilities, 1928.

Montgomery, Rick, and Shiel Kasper. *Kansas City: An American Story*. Kansas City, MO: Kansas City Star Books, 1999.

Moss, Richard J. *Golf and the American Country Club*. Chicago: University of Illinois Press, 2007.

Paxton, Heather. *The Kansas City Country Club: Centennial 1896–1996*. Kansas City, MO: Kansas City Country Club, 1996.

Pearson, Robert, and Brad Pearson. *The J.C. Nichols Chronicle.* Kansas City, MO: Country Club Plaza Press, 1994.

Urban Land Institute. *The Community Builders Handbook.* Reprint, Washington, D.C.: Urban Land Institute, 2000.

Wilborn, Chris. *Where the Streetcar Stops.* Kansas City, MO: Wilborn & Associates Photographers, 1991.

Wilson, William H. *The City Beautiful Movement in Kansas City.* Kansas City, MO: Lowell Press, 1964.

Worley, William S. *J.C. Nichols and the Shaping of Kansas City.* Columbia: University of Missouri Press, 1990.

———. *The Plaza: First and Always.* Lenexa, KS: Addax Publishing Group, 1997.

PUBLIC REPORTS, PAMPHLETS, CHAPBOOKS AND BROCHURES

Bruce, Janet. "The John Wornall House, 1858." Jackson County Historical Society.

Haskell, Harry. "City of the Future: Kansas City's Progressive Utopia." WHMC Charles N. Kimball Lecture, 2008.

Historical American Buildings Survey. "Bernard Corrigan House." National Parks Service, U.S. Department of the Interior, 1988.

"Kansas City Flash Flood of September 12–13, 1977." U.S. Department of Commerce, National Oceanic and Atmospheric Administration, December 1977.

A Story on the Development of the Parks and Recreation Department. Published on the occasion of its Diamond Jubilee, 1892–1967. Kansas City: Missouri Parks and Recreation Commission, 1967.

"What Is a Sears Home?" Sears Archives, Sears Brands, LLC. 2015. Available online at searsarchives.com.

ATLASES AND MAPS

Atlas, Kansas City, Missouri and Environs. Kansas City, MO: Tuttle, Ayers, Woodward, 1925.

Atlas of the City of Kansas City, Jackson County, Missouri. Kansas City, MO: Hottelmann, 1881.

Illustrated Atlas of Jackson County, Missouri, 1877. Independence, MO: Jackson County Historical Society. Centennial reprint, 1977.

BIBLIOGRAPHY

Plat Book of Jackson County, Missouri, 1904. Minneapolis, MN: Northwest Publishing Co., 1904.

Plat Book of Jackson County, Missouri, 1911. Kansas City, MO: Berry Publishing Co., 1911.

Residential Developments in Metropolitan Kansas City by the J.C. Nichols Company. Map and promotional brochure. Kansas City, MO: J.C. Nichols Company, 1967.

Sanborn Fire Insurance Maps, 1939–1958. Sanborn Map Company.

SCRAPBOOKS, SPEECHES, BROCHURES AND ARCHIVAL MATERIALS

Country Club District. J.C. Nichols Investment Company, n.d.

Country Club District: A Fact Book Presented by the Developers. Kansas City: State Historical Society of Missouri, Kansas City, n.d.

Country Club District Bulletin. J.C. Nichols Investment Company. Various issues, April 1919–October 1924.

The Country Club District: Metropolitan Kansas City's Major Residential Area. Kansas City: State Historical Society of Missouri, n.d.

The Country Club Plaza: America's Most Outstanding Residential Shopping Center. Kansas City, MO: J.C. Nichols Company, n.d.

Faye Duncan. "The J.C. Nichols Scrapbooks." State Historical Society of Missouri, Kansas City, 1962.

The Outdoor Art of the Country Club District. Kansas City, MO: J.C. Nichols Company, 1969.

Planning for Permanence: The Speeches of J.C. Nichols. State Historical Society of Missouri, Kansas City.

INDEX

INDEX

INDEX

ABOUT THE AUTHOR

LaDene Morton holds a master's in public administration from the University of Kansas and has studied and practiced community and economic development for more than thirty years in areas all across the United States. Her writing on the history of Kansas City allows her to combine her interests in community development and her love of storytelling. Her previous titles on Kansas City's history include *The Brookside Story: Shops of Every Necessary Character* and *The Waldo Story: Home of Friendly Merchants*. She has also has authored one work of fiction, *What Lies West*, a historical novel about the American West, which was a 2009 WILLA Literary Award finalist. She is a former board member of Women Writing the West and a board member of the Writers Place in Kansas City.

Printed in the USA
CPSIA information can be obtained
at www.ICGtesting.com
LVHW080824011123
762556LV00006B/136